DIANA & NIKON

DIANA

&

NIKON

*Essays on the Aesthetic
of Photography*

BY JANET MALCOLM

DAVID R. GODINE, PUBLISHER, BOSTON

First published in 1980 by
David R. Godine, Publisher, Inc.
306 Dartmouth Street
Boston, Massachusetts 02116

Library of Congress Cataloging in Publication Data

Malcolm, Janet.
 Diana & Nikon.
 Essays originally appeared in the New Yorker,
with the exception of one which appeared in the
New York times.
 Bibliography: p. 163
 1. Photography, Artistic—Addresses, essays,
lectures. I. Title.
TR183.M34 770'.1 78-74547
ISBN 0-87923-273-0

All of these essays originally appeared in the *New Yorker,* except for
"Assorted Characters of Death and Blight," which originally appeared
in the *New York Times.*

Printed in the United States of America

For Gardner

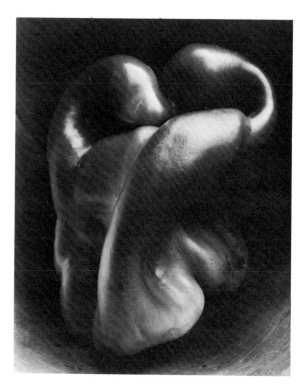

1. EDWARD WESTON, *Green Pepper*, c. 1930.

Contents

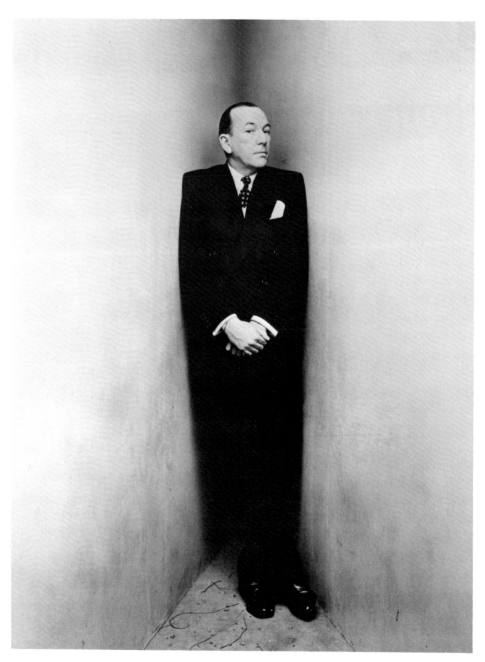

2. IRVING PENN, *Noel Coward*, 1948.

Preface

REREADING THESE ESSAYS (which were written irregularly over a period of four years and, with one exception, published in the *New Yorker*) makes me think of someone trying to cut down a tree who has never done it before, isn't strong, has a dull axe, but is very stubborn. In these pieces, I have been hacking away at the enigma of photography—circling it, trying this side and that, returning over and over to certain yielding places. The relationship of photography to painting, the polarity of the fine-art and the vernacular traditions, the connection between photography and modernism are some of the topics to which I have kept returning, but with changing views. As the depth of the cut determines the stroke of the axe, so my thinking has changed as it has touched deeper levels of the subject.

The arrangement of the essays is chronological. It is only about midway through the volume that I think I begin to get hold of the subject, and in the ninth essay, "Two Roads," that I untangle some of its knottier issues.

My thanks go to John Szarkowski, whose directorship of the department of photography at the Museum of Modern Art has quietly transformed photography from a loose end to a force in contemporary art, and has created a climate in which serious critical writing about photography is possible.

Janet Malcolm

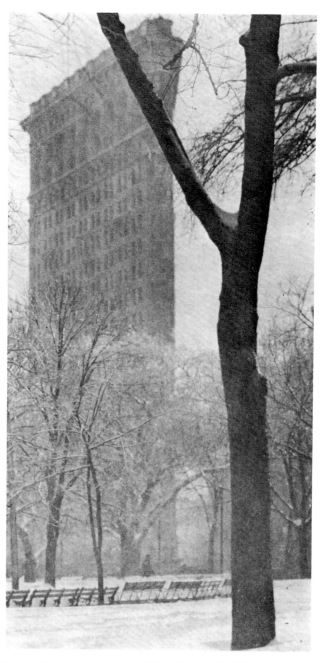

3. ALFRED STIEGLITZ, *The Flatiron Building, New York*, 1903.

East and West

"A WOMAN OF ABOUT FIFTY looks at a Marin exhibition in bewilderment. She turns to Stieglitz: 'Is there someone who can explain these pictures to me? I don't understand them at all. I want to know why they arouse no emotion in me.' Before Stieglitz realizes what he is saying, he replies, 'Can you tell me this: Why don't you give me an erection?' He walks back into his office. The woman acts as though she isn't quite sure she has heard him correctly." Neither is the reader of this passage when he comes to it near the end of *Alfred Stieglitz: An American Seer*, by Dorothy Norman, who for many years was Stieglitz's disciple, assistant, and self-appointed Boswell. Nothing that has come before in the long text has prepared him for it. The man who has all too insistently emerged from Miss Norman's worshipful illustrated biography is a person of such surpassing pomposity, sententiousness, emotional dullness, and Teutonic humorlessness that it is hard to credit him with a coarse mind, let alone with being the most gifted and daring of American photographers and one of the most radical and influential of forces in American modernism. But the photographs are there to confirm the artistic reputation, and so are the facts (though they are none too easy to extract from Miss Norman's over-detailed and undercritical text, and can be better pieced together from such sources as Robert Doty's *The Photo-Secession* and Beaumont Newhall's *The History of Photography*).

Stieglitz almost single-handedly dislodged photography

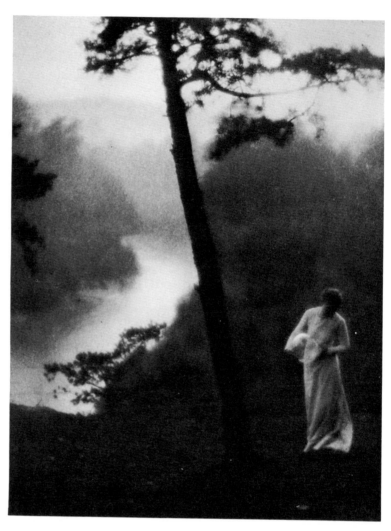

4. CLARENCE H. WHITE, *Morning*, 1905.

from its position at the turn of the century as a kind of genteel hobby, and propelled it directly into the mainstream of modern art. This achievement was carried out in two stages, buttressed by two ideas. At the time, the most advanced photographers were modelling their work on Symbolist, Impressionist, and Pre-Raphaelite paintings, and Stieglitz's first move (in 1902)

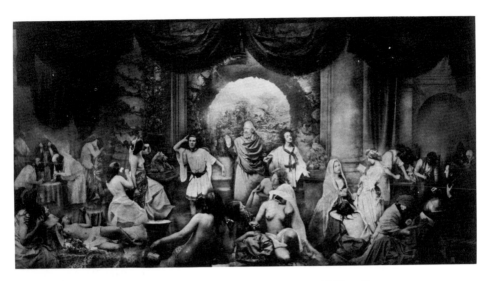

5. OSCAR GUSTAVE REJLANDER, *The Two Ways of Life*, 1857.

was to give this tendency a name—the Photo-Secession. Like Lawrence Alloway's coinage "Pop Art," the label gave definition and direction to something that was not all that definite and direct, and provided both practitioners and public with a point of departure. Today, the Photo-Secession is largely viewed as a misguided attempt to make photography an art form by turning it into a bastard form, and in the light of subsequent achievements—by Strand, Evans, Kertész, Cartier-Bresson, and other modern masters—the portentous, misty landscapes and the blurred, symbolic portraits (achieved by out-of-focus lenses and manipulated negatives and prints) of sad, gowned women [4] and marmoreal, naked children look strained and enervated. But if one goes back to the photography before the Photo-Secession—to the ludicrous anecdotal "art photographs" like Rejlander's "The Two Ways of Life" [5], and to the boring geography-book pictures of foreign cities and landscapes—the pictorial school assumes its proper significance. Although photography soon went "straight" (i.e., photographers put their lenses back into focus and stopped

scratching their negatives and smearing their prints with gum bichromate), it has retained the pictorial formalism brought to it by the Photo-Secessionists. What has changed is the *literalness* of photography's relationship to painting: photographs no longer exhibit the surface qualities of paintings and drawings. But they do retain paintings' formalism, which Stieglitz saw, correctly, as the key to photography's liberation from its mechanical basis and its transformation into an art. His own early photographs—alive and spontaneous in a way that none of his contemporaries could match—invariably displayed this quality in its strictest application. Pictorial formalism as a prerequisite for all else was the real Lesson of the Master.

Stieglitz's second, and truly extraordinary, idea was that of showing the most advanced painting and sculpture of the day at the gallery he had rented at 291 Fifth Avenue to display the work of the Photo-Secessionists. Picasso, Cézanne, Picabia, Rodin, Brancusi, Marin, Hartley, Dove, Maurer, and O'Keeffe were among the artists (then almost unknown in America) that Stieglitz began showing a good eight years before the Armory Show of 1913 "brought" modern art to America. During most of its existence, 291 was the only place in New York where modern art was regularly exhibited, and Stieglitz's pioneering in this regard has been widely acknowledged. What has been insufficiently acknowledged is the importance for photography that lay in the hanging of strange and difficult abstractions alongside the Whistler-like and Redon-like Photo-Secession works. This established photography's association with modernism, which we now take for granted but which was scarcely a historical necessity. It was, rather, a historical accident—the fact that a man of Stieglitz's extraordinary intellectual forwardness (his personal forwardness is something else again) should have entered photography when he did, when there were combination photography-and-bicycling clubs and a museum would as soon have hung a potholder as a photograph. That the Museum of Modern Art formed a department of photography in 1940, that most museums now show photographs, and that an almost automatic interest in photography exists among peo-

ple who consider themselves advanced—all this goes back to him.

Stieglitz was born in 1864, in Hoboken, of German-Jewish parents, and he grew up in a well-to-do, culture-centered household in which, Miss Norman writes, "neither the question of 'being Jewish' nor the meaning of the term was discussed." In 1881, his father decided that he had made enough money (four hundred thousand dollars) and took his wife and six children to Europe for an indefinite period. Alfred enrolled as a student of mechanical engineering at the Berlin Polytechnic, but soon washed out. One day, he saw a camera in a shop window and bought it; before long, he was studying photography at the Polytechnic with a professor of photo-chemistry named Herman Wilhelm Vogel. In 1887, he won first prize in a "holiday work" competition of the London *Amateur Photographer* for a picture he took in Italy and called "A Good Joke." The judge was Peter Henry Emerson, one of the earliest of out-of-focus pictorialists and a champion of the idea of photography as an art form (but who, in a curious reversal, suddenly changed his mind, declaring in 1891, in a black-bordered pamphlet entitled *The Death of Naturalistic Photography*, that photography "must always rank the lowest of all the arts," adding, "I deeply regret that I have come to this conclusion"). In 1887, however, Emerson was still enamored of photography, and he was so impressed with Stieglitz's work that he wrote and told him that his entries were the only good ones in the entire competition. In 1890, Stieglitz returned to America and, for lack of anything else to do, sulkily entered a photo-engraving business that his father had set up for him. It was, he wrote, "an undertaking in which I had no interest," but the idea of being a commercial photographer was "unthinkable." (" 'What?' I said to my father. 'Sell my beautiful prints? No, I will not!' ")

Not surprisingly, the business did not prosper, but Stieglitz's activities in the amateur-photography circles of New York grew. He became editor of *The American Amateur Photographer* and then of *Camera Notes*. During this period, he took some of his most remarkable photographs—the icy night in Central

Park, the Flatiron Building [3], the horse-drawn carriage plowing through a snowstorm—photographs that expanded the technical and thematic possibilities of the medium. In 1893, he married Emmeline Obermeyer, the sister of his partner in the engraving business. According to Miss Norman, the marriage was "ill-fated from the beginning." Emmeline's "timid, conventional approach to life, her lack of interest in anything other than shopping and fashionable hotels—so different from Alfred's complex and adventurous outgoing nature—unnerved him." This passage, like many others, points up the major problem of the book: finding any evidence to support the contention that an adventurous and outgoing Alfred existed alongside the curmudgeon.

Imogen Cunningham once photographed Stieglitz and expressed a wicked satisfaction at having caught "that grim little look in the eye, you know, disliking everything and everybody" [6]. The grim little look pervades Miss Norman's text and glares out of the notebooks she kept while serving at the Stieglitz factory, where disciples, assistants, hangers-on, and tourists came and went, and where, as Miss Norman blandly explains, "if you were not ready, on your own, to undertake what you did in Stieglitz's behalf, or if you could not sense what was right for him, you had better do nothing at all." Her first meeting with Stieglitz would have been most people's last. In 1926, she went to the gallery and tried to buy a Marin, but couldn't get Stieglitz to pay any attention to her. She went back a few days later, and after being told, "Kindly do not handle the pictures!," was again ignored. On the third visit, after meekly standing around and listening to Stieglitz reduce another young woman to tears, she was finally rewarded for her inexplicable patience. Stieglitz turned from the tearful girl to Miss Norman and proudly reported, "This is the third time this week that a young woman has stood here weeping." And "so our conversations began, and so it was that I made a vow to share my experience of Alfred Stieglitz."

Everyone probably gets the Boswell he deserves, and it is probably only fitting that Stieglitz should have drawn a biog-

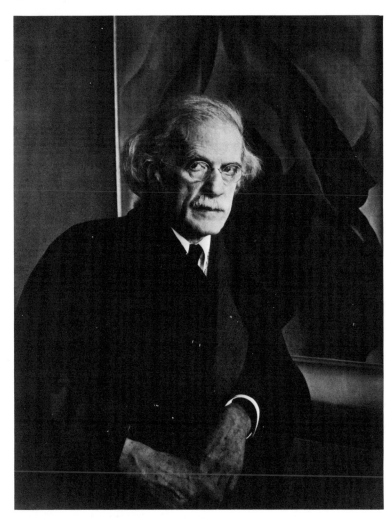

6. IMOGEN CUNNINGHAM, *Alfred Stieglitz*, 1934

rapher who, in her sycophantic innocence, has done a job on him that his worst enemy would have had some scruples about. But poetic justice is not biographical truth. The truth about Stieglitz that has eluded Miss Norman—the answer to the question that is the biographer's reason for being, Why did this particular man do this particular work?—still awaits its Schlie-

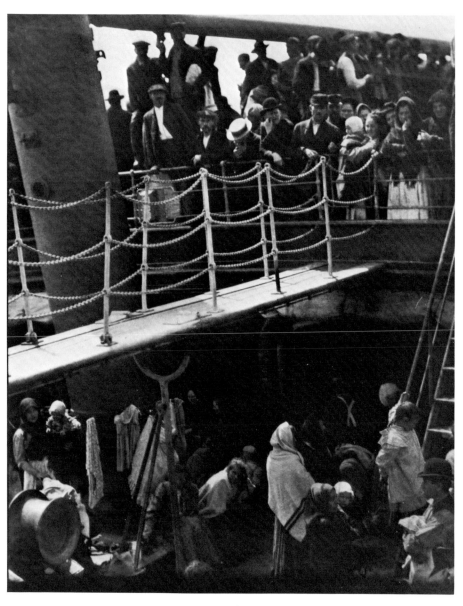

7. ALFRED STIEGLITZ, *The Steerage*, 1907.

mann. Here and there in Stieglitz's writings one gets a whiff of the hidden connection, and in one place—an account of the circumstances under which he took his great photograph "The Steerage"—one feels that one has almost grasped it. He begins with characteristic pettishness:

> *In June 1907 my wife, our daughter Kitty, and I sailed for Europe. My wife insisted on going on a large ship, fashionable at the time. Our initial destination was Paris. How distasteful I found the atmosphere of first class on that ship, especially since it was impossible to escape the nouveaux riches.*
>
> *I sat in my steamer chair much of the time the first days out with closed eyes. In this way it became possible to avoid seeing faces that gave me the cold shivers. But those strident voices. Ye gods!*

Stieglitz presently gets up and takes a walk on the deck. Then, happening to glance down into the steerage, he *sees* his great picture:

> *The scene fascinated me: a round straw hat; the funnel leaning left, the stairway leaning right; the white drawbridge, its railings made of chain; white suspenders crossed on the back of a man below; circular iron machinery; a mast that cut into the sky, completing a triangle. I stood spellbound for a while. I saw shapes related to one another—a picture of shapes and, underlying it, a new vision that held me: simple people; the feeling of ship, ocean, sky; a sense of release that I was away from the mob called "rich." Rembrandt came into my mind and I wondered would he have felt as I did.*

Stieglitz was able to race back to his cabin, grab his camera, and take the picture (God is good to artists: no one had moved) that is one of photography's masterpieces [7]. The peripeteiac account of its creation—the abrupt transformation of the languid snob into the super-artist—is one of art history's illuminations.

The expansive, barefoot, vegetarian, sun-and-sand-centered, womanizing subject of *Edward Weston: Fifty Years,* an illustrated biography by Ben Maddow, presents a considerable contrast to the surly, cape-wearing, mutton-eating, snow-and-rain-loving, monogamous Stieglitz. More to the point, Maddow's book is the lucid, rounded portrait of an artist that the Norman book falls far short of being. It is so fine, in fact, that it raises an unexpected problem: the photographs—so exquisitely reproduced that they almost leap off the page—do not, in their vast entirety, support Weston's reputation as one of the great men of photography. Only a few of the pictures are in the big league: the nudes, the studies of vegetables and shells, some portraits, some landscapes. The bulk of the volume is devoted to the landscapes and the nature studies taken in the thirties and forties, after Weston had abjured abstraction for a kind of Sierra Club realism, which was taken up and pushed to even greater heights of artlessness by such West Coast followers as Ansel Adams, and which represents a reversion to early photography rather than a development of the medium. The combination of sharp focus, tonal richness, and clarity of detail that Weston and the f/64 school strived to achieve in their prints (f/64 is the smallest lens stop) came more and more to be the *subject* of the photograph (in the way that painterliness dominated so many Photo-Secession works) rather than a tool for artistic expression. All too many of these pictures are boring, or, as Stieglitz would say of photographs he had rejected for publication in *The American Amateur Photographer,* "technically perfect, pictorially rotten."

Maddow (not altogether seriously, one would think) writes of the "necessary catastrophe" that was caused by the struggle of photographers to become artists, and he views the Photo-Secession with the distaste and condescension that seem almost obligatory among writers on photography today—and that don't fit the facts. For Weston himself was a child of the Photo-Secession. His first serious work was done in the misty-moisty manner of White and Käsebier, and, as even Maddow grudgingly allows, it wasn't bad. "Edward Weston's loving portrait

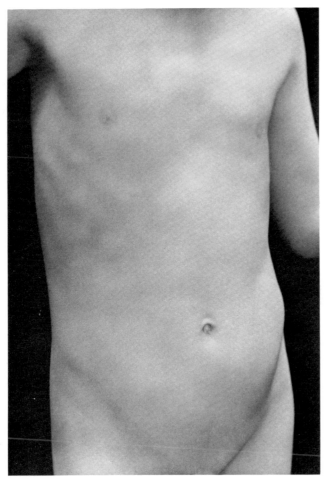

8. EDWARD WESTON, *Torso of Neil*, 1925.

of his partner and mistress (for ten days anyway), Margarethe
Mather, with her bent profile and the vortex of the curves of the
sofa and the sweeping skirt, would be unthinkable in any but
the pictorial style." One of Weston's most beautiful photo-
graphs is a torso of a boy—one of his four sons—which both
transcends pictorialism and affirms its powers [8]. Looking at
this lovely picture—which is cropped at the shoulders and at

9. EDWARD WESTON, *Tina Modotti*, 1923.

the root of the penis—one feels something of the emotion one feels in looking at a Greek statue.

Weston, like Stieglitz (like almost every photographer), entered the medium by chance—when, in 1902, his father gave him a camera—but unlike Stieglitz, he became a professional photographer. He grew up in the Midwest and then emigrated

to a suburb of Los Angeles in 1906 to live with his married sister. He worked at various odd jobs, went to Chicago for a year to study photography, and then, back in California, set up a portrait studio, after having married Flora Chandler, the mother of his four sons. She was for Weston the sort of "mistake" that Emmeline was for Stieglitz (though she gets somewhat longer shrift from Maddow than poor Emmeline got from Norman), and in 1923 he left her and went off to Mexico with the beautiful actress and photographer Tina Modotti. Maddow characterizes this move as the Odyssean "psychic journey" that a man may decide to take between the ages of thirty-five and forty-five, and that is "a circuit of escape from himself that returns him to the home where he started; altered, of course, and not necessarily for the better." The pictures taken in Mexico confirm, rather than refute, the romantic notion that if you leave your wife and children (Weston hedged his bet a bit and took one of the boys along), you, too, can paint pictures like Gauguin or write poems like Shelley. Some of Weston's greatest and most innovative photographs were taken during his "psychic journey," among them portraits of Rivera, Orozco, Tina Modotti, and D. H. Lawrence. There is an entry in one of Weston's *Daybooks* about the portrait of Tina—in which she looks heartbreakingly sad and indrawn, like someone steeling herself against the death of a loved one—that shows how biography can enrich and amplify a work of art [9]. The picture was taken at a time when things were not going well between the two of them (she had other lovers), and on the morning after a frustrating night. They had been about to make up their quarrel in bed when there was an interruption and

> . . . *our mood was gone—a restless night—unfulfilled desires —morning came clear and brilliant—"I will do some heads of you today, Zinnia"—The Mexican sun—I thought—will reveal everything—something of the tragedy of our present life may be captured—nothing can be hidden under this cloudless cruel sky—and so it was that she leaned against a whitewashed wall—lips quivering—nostrils dilating—eyes heavy with the gloom of unspent rainclouds—I drew close—I whispered some-*

*thing and kissed her—a tear rolled down her cheek—and then
I captured forever the moment—let me see f.8=1/10 sec. K 1
filter—panchromatic film—how brutally mechanical and cal-
culated it sounds—yet really how spontaneous and genuine . . .*

He goes on to observe that once "the moment of our mutual
emotion was recorded on the silver film," the release of this
emotion followed, which, as Maddow points out elsewhere, in
writing of Weston's nudes and of how "the model was seen
and photographed in the nude, scrutinized in a preternaturally
bright world of ground glass, and made love to, later," is "a
routine that reverses the experiences of most men."

The vast multiplicity of Weston's love affairs would also
seem to exceed the experiences of most men. Maddow's biog-
raphy is as much the story of a life in love as of a life in art. The
interaction between the two lives, and the integration of them
that Weston achieved (unlike most artist-lovers, who founder
on Yeats's choice), is the center of Maddow's biographical quest
and gives the book its enormous, almost novelistic, interest.
Suggestive of the novel, too, is the firm social setting that Mad-
dow establishes. There is, for example, his evocation of the
group of bohemian intellectuals among whom Weston lived in
Glendale, California, in the twenties, who "went to parties,
drank wine, and made daring excursions together." Among
them were the homosexual intellectual Ramiel McGehee; Mar-
garethe Mather (the mistress of ten days, who was, according
to Maddow, "mostly, though not wholly" a lesbian); the sculp-
tor Peter Krasnow and his wife, Rose; Tina Modotti; and "a
curiously matched couple—the woman was a concert pianist,
and her husband a professional burglar." Writing of the
group's shrill attitude toward middle-class American society,
Maddow observes that "neither he [Weston], nor indeed
Mencken, nor Sinclair Lewis, invented this acidulous view of
America; it was part of the intellectual equipment of the time,"
and goes on to say that their opinions, which "were vulgarized
(if that is possible) in Stieglitz's famous photograph of the rear

end of a castrated horse, which he labeled 'Spiritual America,' "
were not only "violent, bitter, obscene, and indiscriminating;
they were also true. Glendale, in particular, was appalling."

At the same time, California, with its paradisiacal climate
and unreal scenery, was a crucial—perhaps the most crucial—
element in Weston's astonishing liberation from the shackles of
middle-class morality. Men have been known to have Lawren-
cian love affairs in cold, dirty, ugly northern cities—but not
with seven or eight women at the same time, as Weston con-
trived to do when he returned from Mexico and settled in the
beautiful seaside village of Carmel, as its Bunthorne-Mellors.
"Christel Gang, too, fell in love with Weston, and was in love
with him for many years," Maddow writes, and dryly adds,
"Since the affair with Bertha Wardell had just begun, and he
was already sleeping with Kathleen and the *criadas* from Mex-
ico, a certain amount of re-scheduling was necessary." He con-
cludes, "What with Christel, Kathleen, Miriam, Fay, Elisa,
Elena, and Bertha, not to speak of Harriet and another Ruth
(whose surname he never knew)—[Weston] was truly enjoying
the middle-aged Saturnalia of the early-deprived. . . . And
there was still Margarethe, poor melancholy Margarethe." Yet
to come was Sonya, who lived with him for several years, dur-
ing which he produced the great vegetable series, and a few
less serious attachments. Finally, there was Charis.

Weston's marriage to this remarkable woman, who was
twenty-eight years younger, offers obvious parallels to Stieg-
litz's marriage to Georgia O'Keeffe, who was twenty-three
years younger. Miss Norman reveals little more about that rela-
tionship than her approval of it, but Maddow's treatment of the
courtship, marriage, and divorce of Edward and Charis is so
full and intimate that one almost feels abashed by what one
knows about these two *real* people. When they met, in 1934,
Charis obligingly fell in love with Edward just the way Christel,
Kathleen, Miriam, Fay, Elena, Elisa, and the rest had done
before her, but she was "a new sort of person, common in
Europe at the time, but just beginning to flourish in America:

well-to-do, well-educated, quick, frank, aristocratic, but coarse and open about sex and the less interesting functions," and she wouldn't join the chorus of lovesick maidens. After three years of posing for and sleeping with Weston, she wrote him a "moving and courageous letter," as Maddow accurately describes it, in which she asked "Yes or no?"—and he said yes. A photograph of Charis shows a girl in a black beret and a sweater straddling a ladder-back chair, her elbows outthrust and her chin resting on the junction between her wrists; her brow is furrowed, she is staring into the middle distance, and her slip is showing [10]. The composition is striking in its symmetries of legs, arms, and chair posts and ladders, and in the deployment of blacks, grays, and whites. Equally striking is "the thing itself," as Weston called the object of his quest for realism—in this case, the relationship between the model and himself. Unlike the portrait of Tina, which expresses the bitterness and sadness of the relationship, the portrait of Charis, with its comical pose and the girl's mock-serious gaze, expresses the playfulness and courtliness of the relationship between the young woman and the older man. However, in 1945, after eight years of a marriage that friends and visitors regarded as ideal, Charis left Edward. The reason, according to Maddow, was "the unexpungable difference in their ages." The photographer Willard Van Dyke wrote, "I had a feeling that she, being so much younger than he, would not want to stay with him forever. She had a right to want to have children, and he had had his children." By this time, Weston had begun to suffer from Parkinson's disease, which in 1958 was to take his life. Maddow cites a horrible incident that occurred three years before his death, when he was already completely immobilized. The thirty cats that Weston had accumulated and fed with his own hands had got into the house and started a fight that Weston couldn't deal with and that was wrecking the place. His sons arrived on the scene and chased the animals out, then Brett took a rifle and systematically killed the cats, one by one, as Weston listened to the shots from inside the house.

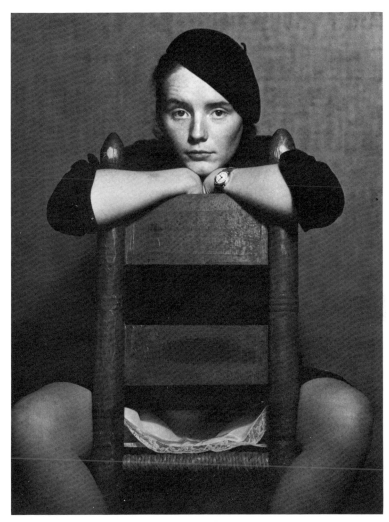

10. EDWARD WESTON, *Charis,* 1925.

Maddow never met his subject, and his view of Weston has the commanding detachment (and slight exasperation) of the true unofficial biographer. His book will outlast many of Weston's photographs.

<div align="right">

1975

</div>

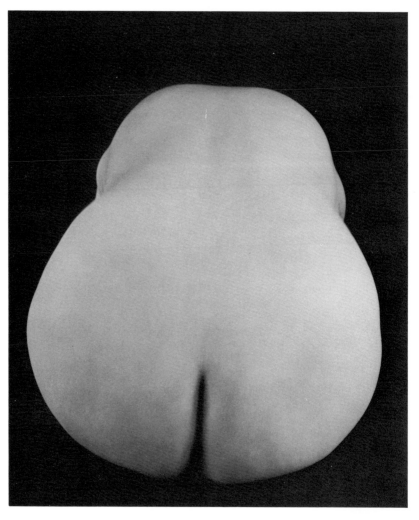

11. EDWARD WESTON, *Nude*, 1926.

Assorted Characters
of Death and Blight

THE LARGE EDWARD WESTON RETROSPECTIVE now at the Museum of Modern Art (it includes 280 prints selected by Weston's friend and one-time disciple, Willard Van Dyke) and a large complementary exhibition at the Witkin Gallery offer a definitive corrective to the notion of Weston's career as a progression from beautiful but empty abstractions to a mature and meaningful realism inspired by the elemental wilderness of California—a notion invented by Weston himself and unthinkingly perpetuated by his followers. "I shall let no chance pass to record interesting abstractions, but I feel definite in my belief that the approach to photography is through realism—and its most difficult approach," Weston wrote in a much quoted entry in his *Daybook* of 1924. A year and a half later, somewhat to his consternation, he created a dazzling series of nude abstractions —among them the famous pear-shaped nude [11]—and for the next two decades intermittently and fortunately continued to revert to the "not so fine use of my medium" on which his artistic reputation rests.

12. EDWARD WESTON, *Cloud*, 1924.

Like Weston, Van Dyke has built better than he appears to know (in his introduction to the museum exhibit, he writes of how Weston "matured as an artist" at Point Lobos, having shed his former "assertiveness and self-conscious artistry"), and he has heavily weighted his selections toward the abstract works, keeping the show fairly, if not entirely, free of the "ain't-nature-grand" (as the photographer once styled it) kind of photograph that Weston gravitated toward in the last part of his career. Weston's major works (most done in the 1920's and 1930's) are the nudes, vegetables, shells, clouds, and landscapes that have been transformed—sometimes almost beyond recognition—into pure, cold, perverse, unmistakable Weston abstractions.

The sight of these strange, strong compositions casts doubt on another accepted idea about Weston. This is his presumed

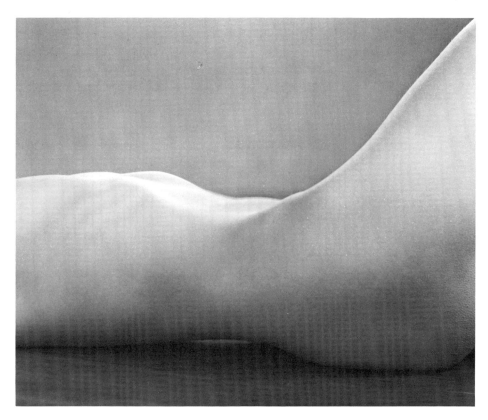

13. EDWARD WESTON, *Nude*, 1925.

role in the history of photography as a prime mover in the revolution that overthrew the "pictorial" approach of the Photo-Secession and established "straight" photography as the medium's legitimate mode. In actuality, what Weston did (as Paul Strand and Man Ray had already begun to do) was simply to bring pictorialism up to date: to replace the Impressionist, Symbolist, and Pre-Raphaelite models of the Photo-Secession with those of Cubist, Futurist, Dadaist, Purist, and Surrealist art. Straight photography—whatever it is—is hardly exemplified by peppers like clenched fists [1], thighs like shells, shells like vulvas, cloud formations like elongated torsos [12,

14. EDWARD WESTON, *Palma Cuernavaca, II*, 1925.

13], palm trunks like industrial smokestacks [14]—forms that Weston saw because he had seen modern art. (Indeed, Weston's work presents one of the strongest cases there is for view-

ing photography as an ancillary rather than a primary form—one that is tied to painting and sculpture and always a few steps behind them.)

The technical innovations of straight photography that were erected into a kind of religion by its practitioners—the change from soft-focus to sharp lenses, from manipulated to unretouched prints, from warm and soft to cold and glossy printing paper—were, again, changes dictated by the appearance of modern art rather than by the claims of "reality." Optical sharpness, after all, is more an attribute of the buzzard's than of the human eye; Stieglitz's blurry view of the Flatiron Building on a snowy day is surely a more literal rendering of "the thing itself" than Weston's razor-sharp close-up of a halved artichoke.

Yet another alteration in thinking that the retrospective invites concerns the relationship between Weston's work and what we know about his life—and we know quite a lot, thanks to the intimate *Daybooks* that he kept between 1922 and 1934 and to Ben Maddow's fine biography. The picture of Weston that emerges from these sources—of a vital and virile romantic who lived a life of physical simplicity and emotional richness in warm climates with one beautiful woman after another; who had the courage to leave his wife and children and go to Mexico with his mistress, Tina Modotti; who finally found the love of his life in his second wife, Charis; who enjoyed the friendship of such artists and intellectuals as Diego Rivera, José Orozco, Robinson Jeffers, and Ramiel McGehee—is at curious odds with the static, indrawn, remote, and sometimes even morbid character of the photographs.

The nudes are strikingly sexless and impersonal. They are bodies (usually faceless) or parts of bodies transmuted into forms that follow no mere human (or sexual) function; even those showing pubic hair show it with formal rather than erotic intent. A well-known photograph of Charis stretched out face-down on the sand—one of Weston's most apparently straight-forward nudes—has an attenuation, a starfish-like quality of inanition that is evocative of death and sleep rather than of

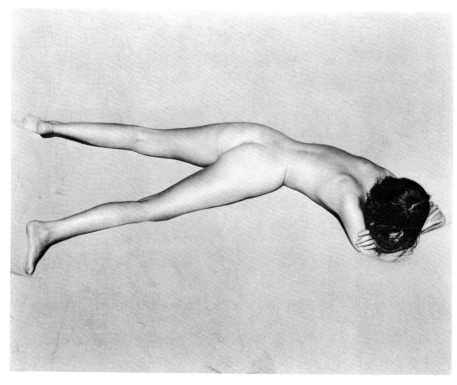

15. EDWARD WESTON, *Nude, Oceano, California*, 1936.

lovemaking [15]. The close-ups of radishes [16] and bananas and urinals, the arrangements of rocks and kelp and dead birds, the wind-swept dunes, the desert hillocks, the roots of cypress trees have a similar hushed deadliness, redolent of the "assorted characters of death and blight" in Robert Frost's scary poem "Design."

As one rereads the *Daybooks* and the biography under the weight of these impressions, one's sense of Weston darkens; one gets the feeling that he didn't enjoy himself very much. (What artist does?) He was happy at the start of a love affair ("The idea means more to me than the actuality," he confessed, and pondered, "Is love like art—something always ahead, never quite attained?"); when intoxicated (or *borrachito*, as he

16. EDWARD WESTON, *White Radish,* 1933.

liked to call it); when in the presence of beauty ("I received by mail from Christel a box of lilacs, white and lavender, so exquisite that my eyes filled with tears"); when doing "my work," in contradistinction to the portrait photography he did to earn his living. (It would be interesting to see examples of the commercial work and compare it to the portraits, done for art's sake, of

his friends and family.) But far more frequently than happiness, the *Daybooks* express the anxiety and loneliness and eccentricity that underlay and undermined the surface exuberance and gregariousness and conventional bohemianism. The entries written during the romantic trip to Mexico are pervaded with worry about money, housing, equipment; with sorrow about the deadness of his feeling for Tina (which Weston was to feel toward all the women he loved); and with guilt about the three children he had left behind. (In a film based on the *Daybooks* that Robert Katz made for public television in 1965, there is a painfully moving scene in which Neil, the second-youngest son, talks of how he felt during his father's desertion; the camera, focused on his face, reveals how much it still hurts.)

The *Daybooks* written on Weston's return from Mexico continue to reflect the alienation from family, friends, and lovers, and from the cultural and political life of the time, that Weston felt—an alienation that seems to be one of the preconditions of producing art in this country. A small, but telling, detail is the repeated reference in the *Daybooks* to the vegetarian meals Weston enjoyed ("supper: *aguacates,* almonds, persimmons, dates, and crisp fresh greens")—always accompanied by a reference to the gross steaks or greasy pork chops that other people eat and that he had narrowly escaped from, as if his enjoyment of one depended on the repudiation of the other. A similar though less explicit polarity is set up between the lithe, ever-younger girl Weston fell in love with and the threatening "hog-fat" bourgeoise American woman, into which category his abandoned wife, Flora, evidently fell. (One is reminded of Humbert Humbert's distaste for grown-up women, like Lolita's mother, in comparison to nymphets.)

In 1944, Weston contracted Parkinson's disease, which took his life in 1958. "Whatever has happened to me, I've brought upon myself," he said of the illness, prompting Maddow to observe

astutely, "It is not astonishing that he attributed the fault of his (then) incurable disease to himself; for if one brings it about, one can, perhaps, undo it." And yet there is another dimension to Weston's feeling about his final illness. A film made by Van Dyke in 1946 for the U.S.I.A. and intended for distribution in twenty foreign countries shows Weston in the first stages of the disease, his gait a slow shuffle, his expression frozen and mask-like—a ghostly figure not really there, impervious to the bouncy young people with 1940's clothes and 1940's smiles who posture around him, to the mindless chatter of the propagandist narration, to the dated crescendos of the background music. The film is a depressing example of the drivel we were sending abroad at that time, and a depressing look at a sick man. It can also be taken as a metaphor for the condition of the artist—who, out of step with his time and locked in a prison of his own making, escapes time's depredations through his art.

1975

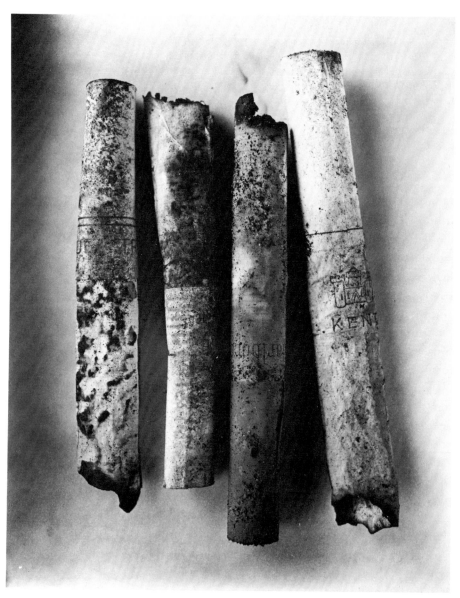

17. IRVING PENN, *Cigarette No. 86*, 1972.

Certainties and Possibilities

IN HIS FIRST ONE-MAN SHOW at the Museum of Modern Art, Irving Penn—the photographer of Mumm's champagne, *Vogue* models, Peruvian peasants, small-tradesmen, and famous writers, artists, and statesmen—is represented by fourteen surprising and strange photographs of what might appear to be eroded stone columns or neolithic implements or diseases of the bone and are in fact photographs of cigarette and cigar butts [17]. The enormously enlarged images are printed on platinum paper (this medium, which went off the commercial market some forty years ago and is today being painfully re-created at home by a few photographers, brings out the rich range of middle tones that eludes silver printing), and this abets their appearance of solidity and mass and gives them their gray, vaguely scientific aspect. The butts (there are between one and four in each composition) are arranged as if they were people sitting for a portrait by Penn—and, indeed, as one scrutinizes these pictures one realizes that Penn has not departed from his characteristic photography but has simply extended it to an uncharacteristic subject. Or not so simply. For a satiric intention gleams out of the show which gives these beautiful and boring pictures their collective pointedness and invests this quiet occasion with the shimmer of an Event.

The satire has two objects. One is art photography itself, of

which the MOMA is the leading, if no longer the solitary, salon. The keepers of the "photography-as-an-art-form" flame (currently the somewhat astonished custodians of a blazing bonfire) have traditionally excluded commercial photography from the pantheon of camera-work supporting photography's artistic claims, and photographers themselves have distinguished between any work they might do for money and the pictures they take for art. Alfred Stieglitz, dean of American art photography (who also happened, almost as an afterthought, to be one of the greatest of American photographers), absolutely refused to do commercial work, and Edward Weston, who didn't have Stieglitz's financial resources and earned a precarious living from studio portraiture, strenuously differentiated between the portraits and what he called "my work." Art photography in this country has, in effect, been photography as a spare-time activity (stretched out by occasional assists from the Guggenheim Foundation)—a situation resembling that of poetry here, with this difference: while there are no real poets making big money from their verse, a number of good, even great, photographers (e.g., Penn and Richard Avedon) have been serenely raking it in from the fashion magazines and advertising agencies while producing work as rigorous and innovative as anything being done today. But by not playing the art-vs.-money game—their commercial work is their art—these obvious candidates for museum shows have been passed over. Avedon finally cracked MOMA last year with some off-hour pictures of his dying father; they evidently turned the trick that his nine-to-five pictures of lipsticks and navels didn't, and now Penn does it with his butts. "See how arty I can be" is their mocking message to all those who have dismissed Penn as a hack and have used words like "slick" and "commercial" about his work. John Szarkowski, director of the museum's Photography Department, takes the bait and, in the wall label he wrote for the show, reverently welcomes Penn into the fold of avant-garde art. He gets around the embarrassment of the fashion pictures and the gourmet ads by blandly observing of Penn, "One might guess that he has only rarely enjoyed more than a

cursory interest in the nominal subjects of his pictures. For him the true subject has been not haute couture or cuisine, but line, tone, shape, and pattern, and the photographic intuition that will define their just relationship."

For Szarkowski, however, the subject of the butt pictures is surely of more than cursory interest: it is the large, if not the whole, reason for his mounting the show. His directorship has been marked by a predilection for work of a looser and rougher sort than the art photography of the past—work that is at odds with the elegant pictorial conventions established by the Photo-Secession, and that takes its cue not from painting but from such bluntly utilitarian and uniquely photographic forms as the snapshot, the aerial photograph, the medical and scientific illustration, the police photograph, and the album portrait. Szarkowski has extended to photography (as he acknowledges in his book *The Photographer's Eye*) the loaded polarities of the "functional" vs. the "cultivated" that John A. Kouwenhoven offered in his study of American culture *Made in America*, and he has embraced the change in taste that Kouwenhoven's work helped to form (for example, today's exaltation of things like quilts, farm implements, vernacular architecture, and scientific instruments). Penn's pictures of butts exhibit all the rough oddity of the found art object that emerges from the enlargement of a murky detail in a torn, unregarded snapshot or of a quaintly drab illustration in an old textbook; they partake of the transformation that quilts and ship propellers and industrial tools undergo when they are wrested from their functional context and put on show for their aesthetic qualities. And they suffer from the same paradoxical devitalization that comes over useful objects when they are no longer *in* use. The tacky machine-made synthetic comforter on the bed has more connection with life—is more genuine, in its way—than the handsome antique quilt that hangs on the wall as if it were a painting, and in this respect Penn's sleek pictures of clothes and caviar in *Vogue* and *Harper's Bazaar*, far from paling before the rough vigor of his pictures in the museum show, present a kind of rebuke to the latter's false vernacularism.

18. IRVING PENN, *Jean Cocteau*, 1948.

The second object of Penn's subtle mockery is himself. These pictures have the self-critical and confessional dimension of books like Henry James's *The Sacred Fount*, in which the writer gamely knocks over his own painfully contrived artistic edifice (lest someone else get there before him, perhaps); they express Penn's mordant understanding of the extremism of his photographic methods. Unlike Weston's peppers and cabbages, which celebrate Weston's religion of "the thing itself"

19. IRVING PENN, *T. S. Eliot*, 1950.

and permanently alter one's vision of these vegetables, Penn's
butts efface reality. One looks in vain in one's ashtray for any
evocation of the exhibition; at the show itself, in fact, one
adduces the subject matter only from the faint telltale lettering
of the brand names. And so with Penn's portraits, which are
first of all *Penns* and only incidentally pictures of individuals—
Jean Cocteau [18], T. S. Eliot [19], and Noel Coward [2] being

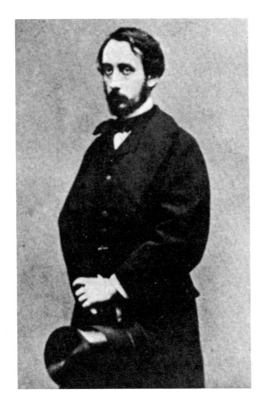

20. PHOTOGRAPHER UNKNOWN,
Edgar Degas, c. 1862.

as interchangeable as Kents, Lucky Strikes, and Marlboros. Penn removes people from their own context and treats them like botanical or zoological specimens. He lures them into his studio, sits them on cloth-draped structures, subjects them to a north light that shadows half of each face, and sometimes literally pushes them into the corner that his brutal direction has put them in emotionally. In Aaron Scharf's *Art and Photography* —a work tracing the complex interrelationship of photography and painting, with emphasis on the influence of photography on painting rather than vice versa—two pictures are shown side by side to illustrate the use that Edgar Degas made of photography. One is a *carte-de-visite* photograph of the painter taken in 1862 [20], and the other is Degas's self-portrait of 1862,

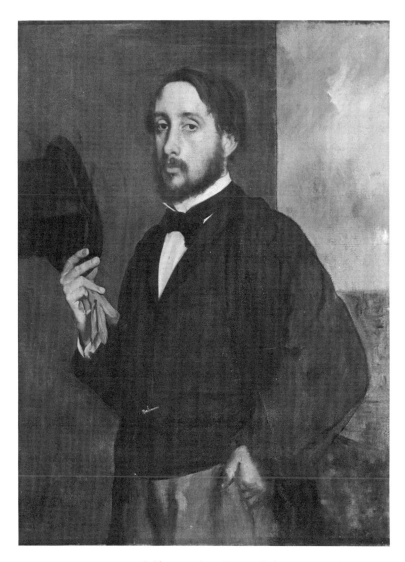

21. EDGAR DEGAS, *Self portrait, "Degas Saluant,"* c. 1862.

known as "Degas Saluant" [21]. The first shows a bearded
young man in a dark suit holding a top hat and looking like a
glum cousin in a nineteenth-century family photograph album;
the second (in spite of its small size, poor quality of reproduc-
tion, and black-and-whiteness) is an unmistakable, unforget-

table, gooseflesh-making Degas. The claims of photography seem puny indeed in such a conjunction. It is Penn's enormous achievement to have coaxed a photographic style as strong and personal as a painting style from a medium whose natural tendency is to obscure and dilute the imprint of its practitioners. But the question remains—one that Penn himself seems to be brooding about in this show—whether such violent stylization is not a perversion of the true business of photography. In *Worlds in a Small Room,* his collection of pictures taken around the world (in New Guinea, Morocco, Crete, Cuzco, San Francisco, and elsewhere, sometimes in a portable studio), Penn complacently and condescendingly writes, "Taking people away from their natural circumstances and putting them into the studio in front of a camera did not simply isolate them, *it transformed them.* . . . As they crossed the threshold of the studio, they left behind some of the manners of their community, taking on a seriousness of self-presentation that would not have been expected of simple people." With his butt pictures Penn shows that he has the capacity for self-doubt one expects of complicated artists.

Garry Winogrand is a leading member of the opposition to posed and stylized photography like Penn's; he is a maker of pictures so raw and uncontrived that the unforewarned could take them for snapshots. Winogrand (who has been a commercial photographer, is now a photography teacher at the University of Texas, and does his real work in his spare time) objects to the very idea of professionalism—to the traditional distinction between the professional as someone who can control and predict his results and the amateur as someone who fumbles around and sometimes gets a good picture by accident. Answering a student who had asked "What is it, say, in a picture that makes it interesting instead of dead? What makes it alive instead of dead?" Winogrand replied with this telling statement:

Let's go back to that gasoline picture [a photograph by Robert Frank of some gasoline pumps]. Let's say [it's] the photographer's understanding of possibilities. . . . *When he took that photograph he couldn't possibly know—he just could not know —that it would work, that it would be a photograph. He knew he probably had a chance. In other words, he cannot know what that's going to look like as a* photograph. . . . *That's really what photography—still photography—is about. In the simplest sentence, I photograph to find out what something will look like photographed.*

Winogrand is an acknowledged follower of Robert Frank, whose book *The Americans* has recently been reprinted and reappraised as a seminal work. Like Vladimir Nabokov, the Swiss-born Frank "saw" the America of the 1950's as no native American could have seen it. His bleak, gray, grungy photographs of hamburger joints, car accidents, urinals, motels, ugly Middle Americans expressed—long before Pop and Photo-Realism appeared—the loneliness, alienation, rootlessness, and sadness of automobile-happy mid-century America. No one had ever made pictures like that before, and it took a while for their irony to sink in: Frank couldn't find a publisher in America until the collection had been printed in France. Frank subsequently abandoned still photography, made films, abandoned that career, and now lives in isolation in Nova Scotia. He has recently started fooling around with Polaroid snapshots.

Winogrand picks up where Frank leaves off. In his book *The Animals*, he shows the Central Park Zoo for the dirty prison it was, focusing on the bars, the concrete floors, the dispirited, ugly animals, the dumb (for thinking they are enjoying themselves), ugly people, and the grubbiness and meanness, conveying an atmosphere of nakedness and brown-soap harshness like that found in the paintings of Francis Bacon. In his large exhibition at the Light Gallery last March, Winogrand extended this dark vision to the larger zoo of contemporary urban America. He showed—in a fittingly disobliging manner, with his black-edged, buckling prints jammed together four-deep on the gallery wall, so that one had to crouch to see the bottom row—

over two hundred photographs taken between 1952 and the present, most of them on the street, a few penetrating into bars, stores, airport lounges, and living rooms. Each picture is touched with the element of risk that Winogrand courts ("He knew he probably had a chance"), and not every picture is a photograph. (Some look like the pictures one sends back to the lab because it has blown up the wrong contact.) But when a picture works, it is potent indeed. For example:

An old man carrying a plastic-covered garment from the cleaners is stiffly stooping to pick up his cane from the sidewalk. The scene is a poor neighborhood street lined with familiar-looking crumby little stores. The shutter was clicked at the moment best calculated to show the painful slowness *of the man's action.*

A crowded park scene. A young mother dressed in a Pakistani shirt and jeans is striding briskly along, holding a little girl by the hand—practically dragging her. The child, wearing shorts and sneakers and sucking on a lollipop, is pulling back in order to stare at a woman midget wearing a print dress and high black shoes and carrying a cane. Two other kids in the crowd are gaping at the midget. But all the other people in the picture are obliviously going about their park business. The midget doesn't exist for them. Only the children see her; children "see" what grownups no longer can.

A picture taken in a bar, seen down its length. The focus is the mock-incredulous expression on a pretty woman's face as she listens to a man with his back to the viewer, whom she has probably picked up there. A very American woman, a very American expression. (The other—the listening—side of the tall tale.) The alienating length of the bar, like a superhighway, in contrast to the intimacy of English pubs and French bistros.

As these descriptions suggest, Winogrand's work derives from the school of Cartier-Bresson, Kertész, and Brassaï, who pluck their pictures from the flux of street life and fix with their small cameras the fleeting moment that no brush or pencil (or even eye, sometimes) is fast enough to seize. This arresting of time is photography's unique capacity, and the decision of

when to click the shutter is the photographer's chief responsibility. Cartier-Bresson's "decisive moment"—which he waits for like a stalking cat—arrives when (1) the gesture or expression or relationship or anecdote in question is at its highest peak of intensity, and (2) the picture's composition achieves (or retains) the appearance of a formal work of art. Frank's important discovery—one that Winogrand and other younger photographers have adopted enthusiastically—was that you can't get (2) in this country, and shouldn't try. This country is too messy and ugly—there are too many cars, signs, billboards, plastic baby strollers, women in pink curlers, garbage bags, high-rise buildings. These are our equivalents of the linden trees, cobblestones, brass plates, nineteenth-century store signs, nuns, and gendarmes that figure (or figured) in European photography, and they are the true elements of contemporary American photography. Winogrand embraces disorder and vulgarity like long-lost brothers, and often compounds the chaos of his pictures by taking them at radical angles. (A student remarked, "I always feel very precarious when I look at your images. I feel like I'm falling over. . . . Do you often shoot without using your viewfinder?" Winogrand curtly replied, "I never shoot without using the viewfinder.") Further unlike the elegant Europeans, who photograph discreetly and unobtrusively, Winogrand goes clumping right up to people, as one gathers from the startled or disgusted expressions on the faces of many of his subjects. This, too, is not ineptitude but part of the belligerent program of "finding out what something will look like photographed."

A 1961 memo from Edward Steichen, then director of photography at the Museum of Modern Art, which would probably please Winogrand, lies in Winogrand's file at the museum: "Dangerously close to snapshots but have collective impact. Maybe show group in show. Buy 3 at $10 each."

1975

Regrettably, Garry Winogrand would not give permission to reproduce any of his photographs.

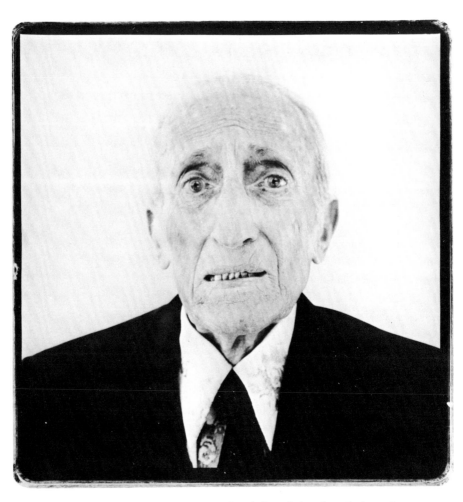

22. RICHARD AVEDON, *Jacob Israel Avedon, father of photographer*, 1973.

Men Without Props

IN MAY 1974, a series of fashion photographs appeared in *Vogue* which caused even the most impassive of vogue-followers to stare with astonishment. The first picture showed a tanned, bare-breasted girl with upraised arms, her chest marked by two glaring white circles created by her discarded bikini top, her rump pressed against the groin of a hairy man whose hand possessively curved around her thigh while his thumb poked into the corner of her bikini bottom, in the other corner of which she had tucked a comb, sunglasses, and a purse spray of the Lanvin perfume that was the nominal subject of the photograph. In other pictures, in aid of other scents, creams, and makeups, the girl lolled in the sand with this man and another one. Sometimes she sprawled over the prostrate body of one while resting her head on the shoulders of the other, or lifted her T-shirt to permit her stomach to be kissed; in a concluding picture, she sat holding up the two men, who seemed to have expired from heat, sex, or sheer boredom. Few readers had to look at the credit line to see who had taken these outrageous pictures. Richard Avedon's career as a fashion photographer—at *Harper's Bazaar* from 1945 to 1965 and at *Vogue* since 1966—has been consistently marked by its extremism and by Avedon's almost uncanny feel for the zeitgeist. In this instance, he had caught and crystallized, in all its unpleasantness and silliness, a moment in our national life when an unlikely but palpable pornographic spirit was in the air.

Although Avedon is one of the best known and least underrated of fashion photographers, his achievement is imprecisely understood. A common misconception—derived from the motion and the animation that are a signature of his fashion work—is that Avedon rescued fashion photography from a sorry condition of mannered rigidity and bloodless stasis and forged it into a medium of vital and forceful naturalism. In fact, when Avedon arrived at *Harper's Bazaar* as a nervous pupil and protégé of Alexey Brodovitch, the magazine's art director, fashion photography was at the peak of its efflorescence and had just passed through a period whose best examples—by, among others, Baron Adolphe De Meyer, Edward Steichen, Cecil Beaton, George Hoyningen-Huené, Horst, Martin Munkacsi, and Louise Dahl-Wolfe—have never been surpassed. The stasis and rigidity that marked the fashion pictures of the twenties and thirties were the result not of ignorance and backwardness but of the stylistic conventions under which photographers, along with other decorative artists of the period, sedulously labored—the rectilinear forms (derived from Cubism, technological design, the Bauhaus, Russian Constructivism, American Indian art, and Aztec architecture, as well as from some of the period's more sinister political movements) that have recently been labelled Art Deco.

Avedon's achievement was to mark the passing of Art Deco and to grasp, before anyone else did, the outlines of its successor, for which a name has yet to be coined, but in whose thrusting curvilinearities we can read a recoil from the deprivations and politics of the war years and a foreshadowing of the escapist tendencies that shaped the next two decades—the privatism and the acquisitiveness; the obsessions with food, sex, children, and objects; the search for the "natural" and the "organic." Even at the start, when Avedon's fashion pictures were no better than those of other fashion photographers—and often, in fact, worse—they looked more *modern*. (Modern in relation to their own time, that is. Fashion photography's status as an art form is vividly demonstrated by a comparison of a fashion photograph of twenty years ago with an ordinary snapshot of a woman dressed in the style of that time; in the snap-

shot the clothes look peculiar and dated, while in the fashion photograph they have the timelessness and inevitability of the clothes in Renaissance or Empire paintings.) Avedon put his models into motion against blurred, smoky backgrounds for the sake not of naturalism but of style: his swirling capes and billowing ball gowns described the curves that major artists were dripping or slashing onto canvases and anonymous artisans were putting into things like sling chairs. Avedon's metaphors similarly drew on the spirit of the time; in place of the classical motifs, the Cubist designs, and the cold trappings of opulence that formed the settings of prewar fashion photography and projected an ideal of aristocratic remoteness and arrogance and languor, he created a no less preposterous but more *haemish* and democratic-looking vision of affluence. His Dior-dressed models strode along the streets of Paris, graciously mingling with shopkeepers, pausing to watch street shows of tumblers and strong men; at night, after the opera, they dismissed the chauffeur in order to gambol down the Champs-Élysées with their escorts and stop in for a nightcap at the Chinese Bar, where they acted as if they were at a Howard Johnson's; in the summer, they flew away not to dreary rich resorts but to earthy fun places like the Temple of Karnak; and when other entertainments failed they stayed home and played with their clothes and makeup, painting and arraying themselves to look like women in Japanese prints or in Nabi paintings (or, perhaps more to the point, in Irving Penn's painterly color photographs).

Avedon's innovations were quickly adopted by other photographers, and just as quickly dropped by Avedon, who, on the Red Queen's principle, was forever running in order to stay in place. Sometimes he ran straight into trouble—most conspicuously in the April 1965 issue of *Harper's Bazaar*, which the magazine had foolishly entrusted to his "guest editorship," and from which it has yet to recover. In this self-indulgent mess, filled with bizarre space-age costumes set against Op and Pop Art backgrounds, with glossaries of "in" expressions like "groovy" and "make the scene," and with long patches of inane cool writing, Avedon revealed what lay on the other side of the

edge he likes to skirt. Soon after this debacle, he moved to *Vogue,* where he was able (or was made) to pull himself together and—as the May 1974 pictures demonstrate—to reassert his dazzling preeminence among fashion photographers.

In that same issue of *Vogue,* a few pages after the sex-in-the-sand pictures, there appeared an even more shocking picture by Avedon: a portrait of his dying father [22], selected from a show of eight photographs then on view at the Museum of Modern Art which Avedon took during the last years of his father's life and which traced, with devastating clarity, the course of Jacob Israel Avedon's incurable cancer. These painful, fearful images of aging and suffering were a culmination of Avedon's corollary career as a portrait photographer, which he has consistently pursued and on which his claim to being a "serious" photographer has rested. This career has passed through several distinct stages.

The earliest portraits, most of them of famous stage and screen personalities, are characterized by their aliveness and (often exaggerated) expressiveness, and by the photographer's conception of the subject as the embodiment of what he does: comedians are shown mugging, singers singing, actors acting, professional beauties being beautiful. At this point, the fashion work and the portraiture are stylistically and emotionally of a piece; both are animated by an innovator's spirit of experiment and risk-taking, and by a young man's wish to please and dazzle. Portraits of Fred Astaire, James Cagney, Alec Guinness, Kay Kendall, Vicente Escudero, Hermione Gingold, Charlotte Greenwood, Marian Anderson [23], and Anthony Quayle are some of the felicities of this exuberant period. Then, in the mid-fifties, Avedon's portraits begin to veer sharply in another direction. His subjects become older, and his camera dwells on the horrible things that age can do to people's faces—on the flabby flesh, the slack skin, the ugly growths, the puffy eyes,

23. RICHARD AVEDON, *Marian Anderson*, 1955.

the knotted necks, the aimless wrinkles, the fearful and anxious
set of the mouth, the marks left by sickness, madness, alcohol-
ism, and irreversible disappointment. These pictures of people
who no longer care how they look—or shouldn't if they do—
were taken under the glare of strobe lights or in bright daylight,
to pick out every degrading and disgusting detail; were often
angled from below, to reveal the collapse of chin into formless
flaccidity or to accentuate the tense, death-rattle attenuation of
neck; and were printed in savage black contrast. Perle Mesta,
Dorothy Parker, Coco Chanel, Isak Dinesen, Father Martin
Cyril D'Arcy [24], and Somerset Maugham were some of the
victims of this merciless inspection; they can be studied in the
books *Observations*, with text by Truman Capote, and *Nothing*

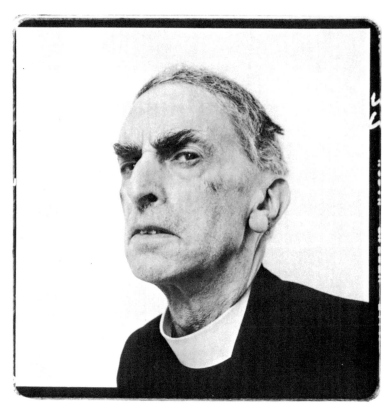

24. RICHARD AVEDON, *Father Martin Cyril D'Arcy*, 1959.

Personal, with text by James Baldwin. These portraits shocked and discomfited their viewers, and many people began to say of Avedon that he was mean and was "out to get" his subject —a reputation that still adheres to him.

A more charitable (and likely) interpretation of Avedon's motives in creating these distressing portraits is to see them as a reaction to the glut of idealized youth and beauty that fashion photography forces on its practitioners, and to the particular illusion of gaiety and pleasure that Avedon's own fashion photographs have fostered. Like the death's-head at the feast in medieval iconography, these pictures come to tell us that the golden lads and lasses frolicking down the streets of Paris today

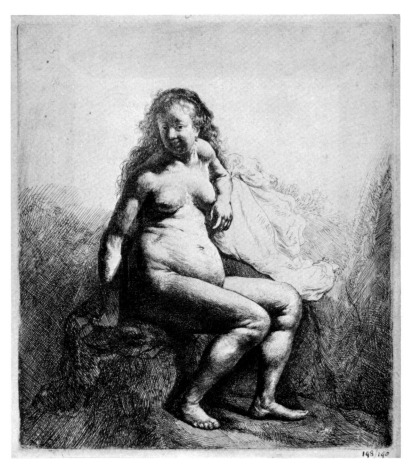

25. REMBRANDT, *Woman Seated on a Mound*, c. 1630.

will be horrible old people tomorrow, that the pursuit of agree-
able sensations and the worship of beautiful objects are all van-
ity. Avedon *means* to disturb and shock with these pictures, in
the way that the young Rembrandt meant to disturb and shock
with his anti-classical etchings of "real women" (such as
Woman Seated on a Mound [25], with her grotesquely large and
flabby stomach and repulsively fat thighs, on which every
crease, bulge, and even garter mark is shown), and in the way
that the aging Swift did in his disgusting poem "The Lady's
Dressing Room," with its horrific inspection of the lady's dirty

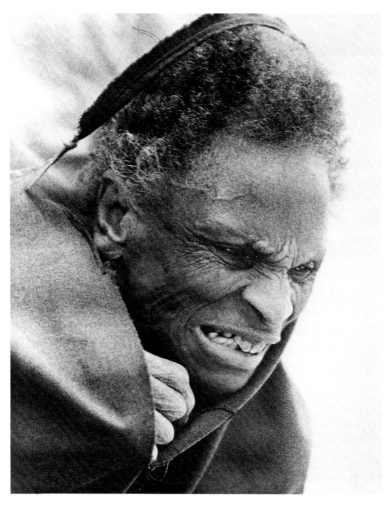

26. RICHARD AVEDON, *Mental Institution*.

secrets and its infamous lament, "Oh! Cælia, Cælia, Cælia
shits." Avedon's portraits of this period belong within this
fierce didactic tradition; their savagery is directed not at the
subject (he irritably points this out himself with his title *Noth-
ing Personal*) but at the vanity and hypocrisy of society. A series
in *Nothing Personal* taken in a mental institution [26]—includ-
ing some of the most awful and powerful photographs of this

kind in existence—hammers home the point, and also seems to be Avedon's own penance for his involvement, as a fashion photographer, in the bazaar of false values in which affluent America trades.

Avedon has passed out of this railing and self-flagellating state, and for the past few years has been working in a new vein of portraiture, whose results, along with some carefully selected work of the past, are currently on view at the Marlborough Gallery. The recent portraits, all taken in daylight, are gentler and softer, and reflective of a larger intention, than their predecessors. Avedon now seeks the universality that is the portrait painter's difficult but achievable goal and the photographer's near-impossibility. Edward Lucie-Smith, in his study *The Invented Eye*, acutely expresses the difference between the two mediums, observing that whereas "a portrait produced by a painter or sculptor is always a synthesis of impressions, and we assume that the artist is attempting a definitive view of the sitter—a verdict," the photographic portrait is limited to one impression and thus leaves the viewer with a sense of "the possibility of other views, other aspects of the sitter." A few photographers, nevertheless, have managed to break through the barrier of the partial view, and one of these masters—the German photographer August Sander (1876–1964)—has been selected by Avedon as a model for his own attempt. Sander, a commercial studio photographer, set out with characteristic Teutonic thoroughness to create a collective portrait of humanity by photographing every "archetype" he could find in Germany; he started out with the peasants and farmers in his native Westerwald and proceeded to artists, writers, statesmen, musicians, actors, shopkeepers, factory workers, industrialists, circus people, Nazis, and so on. Several hundred of Sander's portraits were collected in a book called *Men Without Masks: Faces of Germany 1910–1938*, with a foreword by Golo Mann

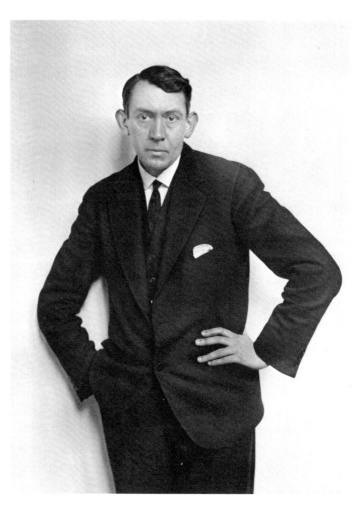

27. AUGUST SANDER, *Richard Seewald, painter,* 1928.

and a text by Sander's son. Anyone who expected to find a
Grosz-like indictment of a nation in this collection of pictures
received instead a chastening and complex statement about the
human condition. Sander's portraits, marked by great beauty,
simplicity of form, and veracity of emotional content, are per-
meated with a *sadness* that comes across not as a passing feeling
experienced by the subject (or as a national characteristic) but
as the permanent condition of mankind. Sander shows us that

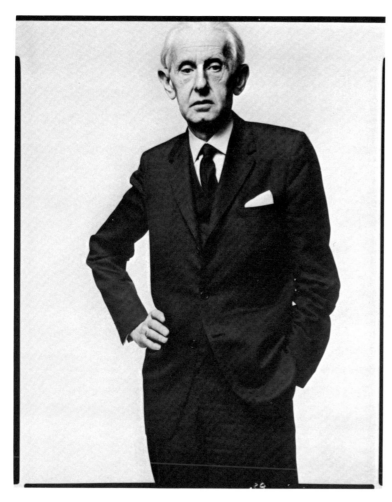

28. RICHARD AVEDON, *Dr. Lothar Kalinowsky, psychiatrist,*
1970.

the human face in repose is tragic. When we remove the masks
that we assume as social beings, we are left with our unalterable
loneliness and alienation.

Avedon's identification with Sander is evidenced by the
archetypal labels he planned, and inexplicably abandoned, for
his portraits at Marlborough (identifying each subject simply
as "writer," "actor," "secretary," "president," "professor"); by
his adherence to Sander's formal head-on poses and eye-to-eye

contact with the subject; and by the unrelieved sadness that runs through the selections [27, 28]. But Avedon's show at Marlborough produces a very different impression from that of *Men Without Masks*.

The most striking difference is the enormous size of Avedon's prints (some portraits have been blown up to as much as forty-nine by sixty-one inches, with the average size being around twenty by thirty), which gives them a quality of impressiveness—almost of grandeur—that is never present in what we think of as the normal eight-by-ten- or eleven-by-fourteen-inch print. (This is leaving out of account, for the moment, three colossal, mural-size group pictures, which dwarf even the largest portraits.) The size of the pictures reflects, again, Avedon's instinctive feel for, and ability to connect with, the broader stylistic currents of the time; the show bristles with its connectedness to the morphologies of Warhol's "Chairman Mao," Christo's valley curtain, Smithson's earthworks, Chuck Close's Photo-Realism, the realism of William Bailey. More consciously and deliberately (and, again, characteristically), the prints reflect Avedon's grasp of the crucial importance of scale in the exhibition of photographs. Avedon has studied (as many gallery owners and museum curators have yet to do) the difference between photography as a publishing form and photography as an exhibition form, and with this show he offers an object lesson in the conduct of the latter. Avedon didn't just send his photographs to the gallery, as photographers usually do, but created the show expressly for the large white spaces and architectural features of the Marlborough rooms. Marvin Israel was hired to design the maze of partitions that permits the showing of more than a hundred pictures, and to lay out a scale model of the gallery in Avedon's studio, so that the relationship of each print to its space and to its neighbors could be premeditated and perfected. As with scale, so with print quality: the prints in the show were made specifically for it (and under a set of criteria different from those governing the prints made for publication in magazines) at the Modernage laboratories, under the supervision of Avedon's chief technician,

Gideon Lewin, and at Avedon's studio, and they are of an exquisiteness that sets a standard for exhibition printing. Nothing could be more alien to the fetish of inexpensive equipment and simple darkroom technique so beloved of the great and near-great of photography (Weston was proud of his five-dollar camera, and Stieglitz's darkroom was like a schoolboy's) than Avedon's D Day-like preparations for this show, in which every modern technological resource was utilized, thousands of dollars were ungrudgingly and carelessly spent, and spates of technicians, assistants, and secretaries were employed.

An on-the-face-of-it-puzzling affinity that Avedon says he feels with Julia Margaret Cameron—whose blurry, exalted portraits of Victorian poets and little girls seem entirely unlike Avedon's incisive, existential examinations of twentieth-century people—makes sense in regard to the boundlessly energetic, stop-at-nothing working techniques of the two photographers. Cameron recruited her hapless family for her photographic ventures in the same way that the richer Avedon recruits his paid employees, and nothing deterred her. For example (one of many such anecdotes related by her biographer, Helmut Gernsheim), the night before the poet Henry Taylor visited the Cameron house, on the Isle of Wight, Julia decided that the guest room was too dark for such a luminary to stay in, so she engaged carpenters to work all night adding a west window in time for the sunshine to be pouring in at the poet's arrival the next afternoon. For Avedon, too, nothing is impossible: he spent seven weeks in Saigon waiting for the members of the United States Mission Council, which was running the war in Vietnam, to come together for the picture he had specially flown out to take, and he twice drove out to Rockland County to photograph Alexandra Tolstoy, Leo Tolstoy's ninety-one-year-old daughter, because he didn't like the dress she had worn at the first sitting. (The second time around, he managed to sort through her closet.) And a week before the Marlborough show opened he decided that the metal screws holding the frames together were wrong, and he and his staff spent a frantic two days looking for plastic replacements. (They

were finally unearthed in New Rochelle.) Yet one feels a subtle difference between the stories about Cameron and those about Avedon; while her extravagances emerge as the endearing willfulness of a lovable old eccentric, his have something of the offputting compulsiveness of the boy who *has* to get an A in everything.

The portraits invite a similar antagonism. They bluntly raise (as Sander's portraits entirely evade) the question of the subject's attractiveness. From most of the pictures at Marlborough one gets the decided feeling that the subject looks considerably better in real life than he does here, that out of hundreds of possible aspects Avedon has chosen the least favorable one, that these enormous, artful pictures are really a kind of apotheosis of the "bad" picture of ourselves that we hastily pluck from the pile of snapshots to be pasted in the album—in contrast to the "good" selections that spare us the sight of our double chins, sunken cheeks, puffy eyes, bad complexions, peevish expressions, and so on. Although Avedon's approach has changed (he no longer photographs from below, or prints in the old dark, cruel way), his intention still seems unkind.

In fact, however, Avedon does not try to make people look bad; he simply doesn't do anything to make them look good. By eschewing all the painterly devices of lighting, pose, background, and printing that can produce a pleasing likeness—by simply taking straight pictures in the manner of a police photographer—he shows us to ourselves not as others see us but as the camera sees us. Like Muybridge's photographs of horses in motion (which revealed that the way horses had been drawn in art was all wrong), Avedon's pictures of men without props present an unpalatable truth. They show us that we are ugly creatures, and that as we get older we get worse-looking, marked by the indignities rather than the nobility of aging. Just as Muybridge's motion studies contradicted timeworn conventions of draftsmanship, so do Avedon's pictures contradict the humanistic traditions of portraiture; and just as many of Muybridge's contemporaries dealt with the embarrassment of his findings by stubbornly denying their truth (Rodin, for example,

ingeniously argued that the "wrong" position of art is really the "right" one, since it accords with the synthesis of impressions that we get when we view motion—i.e., the eye never sees what the camera records), so do many of Avedon's critics deny the validity of his way of seeing.

To this writer's mind, Avedon's revelations about our poor corporeal condition are true (if not whole) statements about humanity, and are a genuine contribution to the body of photographic work that at once refines and expands the medium. But where Avedon can't be defended, and where he gives his critics all the ammunition they need, is in his persistent use of famous people to make these statements with. Why them? Why Dwight D. Eisenhower, the Duke and Duchess of Windsor, Alger Hiss, William F. Buckley, Jr., Harold Brodkey, Marilyn Monroe, Truman Capote, R. D. Laing, John Lindsay, Jean Renoir, Oscar Levant, Louise Nevelson? Why not ordinary people? An interviewer for the Sunday *Times* asked Avedon this question and received a very metaphysical and entirely uninformative answer about "the secret" that is in every photograph. Avedon's "secret" may lie in a simple and practical fact —namely, that it is easier to get a famous person to sit for a portrait than to stop someone in the street and make the request. The question "Why me?" that the nonentity will ask ("Because I want a man with your kind of skin disorder in my show") is never asked by the celebrity, who already knows— or thinks he knows—the answer. But Avedon doesn't play fair. It turns out that he is in no way photographing the great writer because he is a great writer, or the renowned statesman because he is a renowned statesman, but for reasons of his own, and the discrepancy between the photographer's intentions and the subject's (not to speak of the viewer's) expectations unavoidably colors the work. The look of bafflement—sometimes even of reproach—on many of the faces at the Marlborough show may well be there not as a reflection of their common human predicament but as a reaction to the special predicament they have been placed in by agreeing to sit for Richard Avedon. In the catalogue to Avedon's show at the Minneapolis Institute of

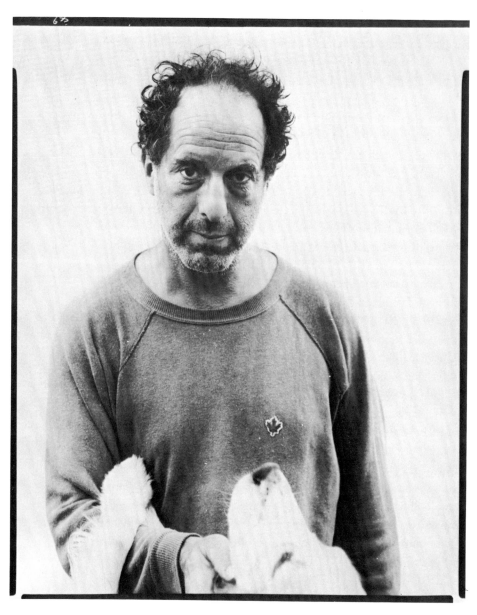

29. RICHARD AVEDON, *Robert Frank, photographer,* 1975.

Arts in 1970, the photographer wrote, "I often feel that people come to me to be photographed as they would go to a doctor or

a fortune teller—to find out how they are." It is doubtful, how-ever, that Edmund Wilson came to Avedon to find out that he was a fat old man whose pants didn't fit, or that Truman Capote came to learn that he was a careless shaver, or that Igor Stravin-sky came to confirm that he was a deathly-sick old man in a wheelchair. In Avedon's pictures of his father, no such discrep-ancy (and dishonesty) was present, and they remain the best works of his career. There are a few people in the show (Vladi-mir Horowitz and Renata Adler, for example, and Robert Frank [29], Jean Genet, and a neighborhood caterer) who exhibit an individuality based on character rather than on peculiarities of physiognomy. One feels, however, that this comes of their own strong photogeneity, rather than of any slackening of the pho-tographer's scientific method.

The three enormous group pictures that loom over the gal-lery (the largest is four hundred and twenty inches by ninety-six)—one of the Mission Council, another of the Chicago Seven, and the third of members of Andy Warhol's Factory—at once diminish the portraits' impact and magnify their prob-lems. The Mission Council picture shows eleven men of various heights, weights, and middle ages, dressed in various gar-ments, standing and facing the camera—nondescript men who could be eleven members of any bank or plastics firm or, if it comes to that, little magazine. The Chicago Seven picture shows seven typically dressed and bearded and mustached young men. The Factory picture, in which several of the hands have taken off their clothes, provides a similar yawn of recog-nition (though one lovely creature with long blond hair, a deli-cately made-up face, and an incongruous penis affords a certain sickening fascination). One feels about these pictures, as one feels about so many of the portraits, that the most enormous and elaborate lengths have been gone to—for too small returns. One finally balks at the low sensationalism that is being offered as high seriousness. A master of the dazzling legerdemain of fashion photography, Avedon remains a pupil of the light-of-day simplicity that is the proper study of the photographer and the glory of photography.

1975

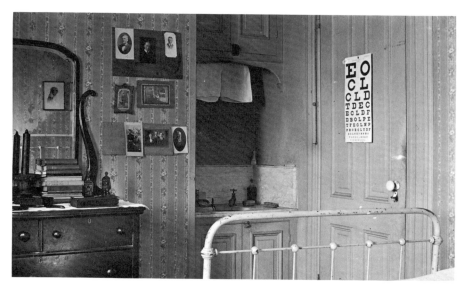

30. PHOTOGRAPHER UNKNOWN, *Bedroom Interior,* c. 1910.

Diana and Nikon

THE HOUSE OF AMERICAN PHOTOGRAPHY has many mansions, which, until a few years ago, were completely sealed off from one another. There was the exalted cult of art photography, founded by Alfred Stieglitz and enshrined first in Stieglitz's beautiful, unreadable journal *Camera Work* and at his 291 gallery, and subsequently at the Museum of Modern Art and the George Eastman House in Rochester. There was photojournalism, brought into being by the Brady group during the Civil War and coming of age in the pages of *Life* and *Look*, where it achieved a universality that photography had never previously enjoyed. There were the various forms of commercial photography: advertising, publicity, textbook illustration, studio portraiture, scientific and technical. There was the special field of fashion photography. There was the field, limited to a few collectors, of antique photography. Finally, scarcely noticed but increasingly ubiquitous, there was snapshot photography, which put the portrait studio out of business as cameras became cheaper and easier to use and families could create their own records of marriages, births, graduations, etc., as well as any less momentous incident of family life at which someone happened to aim a Kodak.

In 1966, John Szarkowski of MOMA had the novel idea of removing the walls between all these compartments and looking at photography whole, as a phenomenon that embraces the family snapshot as well as the Weston pepper, and that has

31. EDWARD WESTON, *Nahui Olin*, 1924.

properties inherent in every photograph taken. With his critical anthology *The Photographer's Eye*, Szarkowski proposed to get at photography's essential nature by examining nineteenth-century *cartes de visite*, newspaper pictures, technical and scientific photographs, snapshots, and other vernacular forms, rather than just the art photographs by Nadar, Cameron, Stieglitz, Steichen, Weston, and the rest. A further novelty of this "investigation of what photographs look like, and of why they

32. JOEL WHITNEY, *Chief Medicine Bottle*, 1864.

look that way" was Szarkowski's idea of plucking the photographs from their familiar contexts as newspaper pictures or snapshots or art photographs and arranging them according to

33. ANDRE KERTESZ, *Billboard,* 1962.

how they might exemplify and illuminate five "characteristics and problems that have seemed inherent in the medium," which Szarkowski had isolated and named "The Thing Itself," "The Detail," "The Frame," "Time," and "Vantage Point."

34. MRS. THEODORE ROOSEVELT, *Theodore Roosevelt Playing Ball with Children at Oyster Bay*, 1894.

Accordingly, in the chapter devoted to "The Thing Itself," Edward Weston's portrait of Nahui Olin [31] appears next to an unknown nineteenth-century photographer's portrait of Chief Medicine Bottle in captivity [32]; in the section on "Time," Henri Cartier-Bresson's "Children Playing in Ruins" faces a picture of some men hanging around a barbershop taken by another anonymous photographer; and under "The Frame," André Kertész's "Billboard" [33] is placed next to a snapshot taken by Mrs. Theodore Roosevelt of her husband playing ball with children at Oyster Bay [34].

A surprising and disturbing impression emerges from this mélange of artistic and non-artistic photographs. One would

expect the artless pictures to suffer when compared to the con-
scious works of art that surround them, but, oddly enough,
they do not. The picture of the Indian chief is as beautiful and
as moving as the Weston portrait; the moment captured by the
photographer in front of the barbershop is no less decisive than
Cartier-Bresson's in the ruins; Mrs. Roosevelt's snapshot may
even have an edge on Kertész's somewhat static composition.
Perusing *The Photographer's Eye* is a shattering experience for
the advocate of photography's claims as an art form. The
accepted notion that in the hands of a great talent, and by dint
of long study and extraordinary effort, photography can over-
come its mechanical nature and ascend to the level of art is
overturned by Szarkowski's anthology, whose every specimen
is (or, as the case may be, isn't) a work of art.

Szarkowski cites John A. Kouwenhoven's seminal *Made in
America*—in which vernacular forms of design, architecture,
painting, writing, and music are resuscitated from neglect, held
up as expressions of our most vital national energies, and con-
trasted with the less vigorous fine-art forms derived from aris-
tocratic European sources—as the inspiration for his approach
in *The Photographer's Eye*. But there is a significant difference
between the two studies. For where Kouwenhoven's examples
underscore the contrast between the "fine-art" and the "func-
tional" traditions, Szarkowski's create the opposite impression
—one of their *sameness*. The "functional" photographs in his
book not only are the aesthetic peers of the "fine-art" photo-
graphs but are in every other way indistinguishable from
them. It almost seems as if every master photograph strainfully
created by an art photographer has an equivalent in the unself-
conscious vernacular of commercial or news or amateur photog-
raphy. The cover picture of *The Photographer's Eye*, for example
—a view of a poor person's bedroom, which one immediately
recognizes as a Walker Evans interior, with its chipped metal
bedstead, cheap wooden dresser, small marble sink, dense
arrangement of photographs on the flower-papered wall, and
(the characteristic incongruous detail that gives Evans's work
its startling metaphorical eloquence) a medical eye chart nailed

35. JACQUES HENRY LARTIGUE, *Beach at Villerville*, 1908.

to the door—turns out not to be by Evans at all but to be a
picture by an unknown photographer found in the files of the
State Historical Society of Wisconsin [30].

Any question of Szarkowski's having mischievously
stacked the deck—of his having illustrated *The Photographer's
Eye* with rare, uncharacteristically artful vernacular works—has
been dispelled by developments that followed the book's pub-
lication. Thousands of vernacular photographs that have since
been unearthed have aesthetic qualities that equal, if they do
not surpass, anything in the book, and show the same singular
lack of stylistic distinctiveness. For where other mediums offer
clear stylistic distinctions between their academic, folk, and
vernacular productions—a Rousseau and a Hicks have their
special quality as primitives that sets them apart from a Rem-
brandt and a Cézanne; thatched huts are different in kind from
skyscrapers; the folk song is distinct from the art song—pho-
tography has neither a primitive style nor a commercial style
nor a reportorial style nor a child's style. There is nothing in
Jacques Henri Lartigue's photography to betray that he was

36. JAMES A. VAN DER ZEE, *Woman with Plume*, c. 1910.

only ten years old when he took some of his most distinguished pictures [35]; or in James Van Der Zee's portraits [36] to show that he was a poor-neighborhood studio photographer rather than a Cecil Beaton (the fact that his subjects were black does, in unfortunate actuality, spell out their social status, but this is sociological rather than photographic information); or in Weegee's famous picture "The Critic" to show that he worked for *PM* rather than for Posterity. The vernacular alternative to the fine-art tradition that Szarkowski set forth in his book (and that he continues to promote in other writings and in the exhibitions he mounts at the museum) proved to be no alternative at all; the quest for vernacular photography that followed Szarkowski's lead has been like an archeological expedition that, digging around Cold Comfort Farm, unearths the Palace of Knossos—and can't quite grasp the significance of the discovery.

Or doesn't want to. For the depreciating implications of these demonstrations of photography's unbounded and undifferentiated aesthetic richness can hardly be lost on the various curators, dealers, collectors, teachers, critics, and practitioners who make up today's photography establishment, and who have a vested interest in keeping photography a manageable, finite art form. If every family album and historical society and old copy of *Life* is a source of art photography (and every camera a potential source), then what is all the trade in, study of, fuss over, writing on, pains taken with photography about? Few members of the photographic community have cared to look at this question (photography has, after all, only just pushed its way into the art market, so why instantly rock the boat?), and most have simply (if nervously) carried on as though nothing had happened—upholding the heavy-breathing traditions of Stieglitz, Steichen, Weston, et al., promoting the equal right of photographs to hang in museums with paintings, cherishing the fine print, distinguishing between good and bad work in terms of the pictorial aesthetic thrown up by a small body of acknowledged masterpieces, and making these masterpieces available to students and lovers of photography, in the way that

the classical repertory is kept before concertgoers.

At the opposite pole, there is a group of avant-garde photographers and theorists who will have none of this genteel, retrograde art-photography stuff, and who, far from seeing the endless sprawl of anonymous, commercial, and amateur pictures as a threatening encroachment and a monstrous competitor, embrace it as a repository of the revealed truth about photography's proper purposes and future directions. This radical school takes Szarkowski's pioneer work to its next logical step, and in repudiating the lessons of the masters of art photography repudiates also the (consciously or unconsciously) art-derived or art-influenced vernacular photographs that appeared to such startling effect in the Szarkowski anthology. Instead, the central focus of this group's researches, and the starting point, model, and guide of its artistic endeavors, is the most inartistic (and presumably most purely photographic) form of all—the home snapshot. The attributes previously sought by photographers—strong design, orderly composition, control over tonal values, lucidity of content, good print quality —have been stood on their heads, and the qualities now courted are formlessness, rawness, clutter, accident, and other manifestations of the camera's formidable capacity for imposing disorder on reality—for transforming, say, a serene gathering of nice-looking people in pleasant surroundings (as one had perceived it) into a chaotic mess of lamp cords, rumpled Kleenexes, ugly food, ill-fitting clothes, grotesque gestures, and vapid expressions.

A look at some of the work being done in this vein and a sense of some of the problems and confusions of this school are afforded by a book called *The Snapshot,* which, according to its editor, Jonathan Green, proposes to examine "the vitality and ambiguity of the naïve home snapshot and its bearing upon a variety of approaches used by contemporary photographers" through a series of articles, interviews, and portfolios. "The photographers represented here are not snapshooters but sophisticated photographers," Green feels impelled to point out. "Yet their intentional pursuit of the plastic controls and

visual richness hinted at in the work of the casual amateur, or their explorations of familial subject matter, involves their work with the ongoing tradition of the home snapshot." Green's introduction is followed by an essay in praise of the snapshot, written by the elusive, legendary photographer and teacher Lisette Model, who dwells on its special quality of innocence—a quality, she feels, that the professional photographer can never achieve: "He may try to imitate the snapshot. He may wait on purpose for the loose, unconventional moment. The moment may be unstructured, but the photographer is not. He may make a masterpiece by selecting the moment but he can never make a snapshot." Model goes on to describe the snapshooter's work: "The picture isn't straight. It isn't done well. It isn't composed. It isn't thought out. And out of this imbalance, and out of this not knowing, and out of this real innocence toward the medium comes an enormous vitality and expression of life." She concludes, "We are all so overwhelmed by culture and by imitation culture that it is a relief to see something which is done directly, without any intention of being good or bad, done only because one wants to do it."

This is all very appealing (if pernicious), but it is a strange statement to put in a book filled with imitation snapshots taken by "sophisticated photographers." However, the pictures by Garry Winogrand, Emmet Gowin, Nancy Rexroth, Robert Frank, Joel Meyerowitz [37], G. Botsford [38], and others that follow flatly contradict Model's contention that snapshots are the exclusive province of the innocent amateur and that the professional "can never make a snapshot." Like the non-art pictures in Szarkowski's book which are indistinguishable from the artistic ones, the fake snapshots in *The Snapshot* are indistinguishable from real snapshots. In the Gowin portfolio are several pictures of a young woman who is always wearing the same glum, closed expression—an expression one instantly recognizes as belonging to a person who hates to have his or her picture taken and is submitting with the worst possible grace to the obnoxious attentions of a snapshooter. (The woman in the fake snapshots is the photographer's evidently genuinely

37. JOEL MEYEROWITZ, *Untitled*.

38. G. BOTSFORD, *Untitled*, 1971.

aggrieved wife.) Garry Winogrand's messy street pictures—full
of litter, parts of cars and buses, cut-off heads, aimless groups
of people, pointless activity—strike a similarly responsive

39. ROBERT FRANK, *Untitled.*

40. NANCY REXROTH, *Streaming Window, Washington, D.C.,*
1972.

chord in the aficionado of lousy snapshots. Robert Frank's terrible Polaroid pictures of his friends are like anyone else's terrible Polaroids [39]. Nancy Rexroth's dreary, gray, blurred little pictures taken with a dollar-fifty toy camera called the Diana ("The company also makes a cheaper model that squirts water when you press the shutter," Rexroth writes) look like the dreary, gray, blurred little pictures that children briefly take with the toy cameras they get for Christmas before turning to more gratifying pastimes [40].

They also look like works of avant-garde art. Photography perhaps more readily than any other medium complies with the Duchampian Dictate—"If I call it art, it becomes art"— whereby a urinal assumes the stature of a work of sculpture. The dullest, most inept and inconsequential snapshot, when isolated, framed (on a wall or by the margins of a book), and paid attention to, takes on all the uncanny significance, fascination, and beauty of R. Mutt's fountain or the bicycle wheel or the bottle rack. Removed from their normal context of the playroom wastebasket and placed in that of an art book, the Rexroth pictures assume the aspect of elegant, ironic studies of pattern, light, texture, and spatial relations; the I-am-Art claims of the other pictures in the book are no less compelling. But here again photography's irrepressible egalitarianism puts its big foot in and kicks the ground out from under the art photographer's position. The philistine who used to come to the Museum of Modern Art and sneer, "I could do that," has been answered; the philistine who comes to the Light Gallery and calmly observes, "I *have* done that," remains an unanswerable, threatening presence.

Photography has never had it so good—prices of prints are soaring, museum exhibitions are increasing, photography books pour from the presses, university departments of photography continue to form, art journals devote more and more space to reviewing photography shows—and the photographer has never had it so hard. Caught between the dead hand of traditional art photography and the shaking, fumbling one of the snapshot school, he may well despair. Some photographers

have dealt with the dilemma by making collages, montages, paintings, drawings, wall hangings, and narratives that incorporate photographs or that employ darkroom processes but are not photographs themselves—have, in effect, left off being photographers. Others, though sticking to photographic methods and materials, have been no less feckless in their use of photography to create imitations of contemporary artwork. (There are Abstract Expressionist, Conceptual, and even Photo-Realist photographs being made.) Everything is being tried, but nothing seems to dispel the malaise that hangs over contemporary photography or the uneasiness, lack of confidence, alienation, and dislocation that afflict the contemporary photographer. With the exception of the late Diane Arbus, no photographer has emerged during the last forty years who can be discussed in the same breath as Stieglitz, Weston, Strand, Cartier-Bresson, and Kertész. It may be that the golden age created by these and a few other masters is a single, aberrant episode in a medium whose truest purposes are fulfilled not by artists struggling against its mechanical grain but by artisans and amateurs letting it call the shots.

1976

41. HERTA HILSCHER-WITTGENSTEIN, *Toni, October,* 1975.

The View from Plato's Cave

A RECENT EXHIBITION OF PHOTOGRAPHS at the Susan Cald-
well Gallery, in SoHo, gave the spectator a rare feeling of being
in the presence of something never done before, and it is a
measure of how far photographers have to go these days to
produce such an effect that the pictures on view—by the team
of Nina Alexander and Herta Hilscher-Wittgenstein—were of a
terminally ill thirty-nine-year-old woman taken during the last
months of her life and after her death. The selection of twenty
images (derived from thousands of negatives) included a pic-
ture of the woman's standing naked torso as it appeared a few
hours after surgery of the breast and abdomen [41], a study of
her face during a seizure of pain, a view of her going down a
hall of the hospital in a wheelchair, a closeup of her embracing
her teen-age daughter, and, finally, views from above of her
corpse on a tray in the morgue and in a wooden casket. The
show was prefaced by a laconic wall sign stating, "Nina Alex-
ander and Herta Hilscher-Wittgenstein met Toni in 1975. In
November, Toni learned that she had an incurable cancer. At
Toni's request, Herta began to photograph her on the day of
surgery, and continued until her death, two months and a day
later. Nina photographed Toni after her death." The enor-
mously enlarged photograph of the incision-slashed torso was
the pivotal image of the show; it compelled immediate, stunned
attention, and its presence invaded one's perception of the

other, less overtly horrifying images. Its horror comes from the fact that it is not a clinical study of a body on an operating table, or a medical-textbook illustration showing a person enduring photography as he does treatment, but a picture of a beautiful young woman posed in a graceful, even slightly vain attitude. She has put a silver necklace around her neck and a bracelet on one wrist. (The other wrist is encircled by a plastic hospital tag.) Her body has the delicate slenderness of a boy's, and the photograph subtly evokes Edward Weston's lovely study of his son Neil's nude torso [6]—it is similarly cropped at the neck and the pubes. The two savage arcs of messy black surgical stitches that rip into the right breast and tear down the abdomen are like obscene marks made on a statue by a vandal. The tense clash of imagery—the brutal yoking of the emblems of pain, pathology, mutilation, and inanition with the attributes of health, wholeness, volition, and grace—is paralleled by a conflict of feeling within the viewer, who is both repelled by and drawn to the image: appalled by the way the woman is exposing what it is "normal" to keep out of sight, and yet fascinated by the details thereby revealed. And, oddly, the closer the viewer looks at the incisions, the less distress he feels; finally, his repugnance recedes and is replaced by something akin to awe for the work of the anonymous surgeon, for the neat and clean way the body has been closed, for the small outward signs of damage.

The transfixing specificity of this image was present in no other work in the show; the other selections moved the viewer not by what they showed but because of what he had been told about the subject's tragic situation. For there is nothing in the picture of the woman's face during a spasm of pain to show that she is afflicted with cancer rather than with menstrual cramps, or in the picture of the embrace with her daughter to indicate that she is going to die rather than leave for a holiday, or even in the pictures of the corpse to make one see that this is real rather than a piece of theatre. The picture story presented here, like those in *Life* and *Look*, requires extra-photographic information by which to convey its meaning; without the intro-

ductory message, the pictures make little impression or sense. Only the photograph of the torso illustrates its own meaning, requires no explanation, has no ambiguity, can be nothing but what it manifestly appears to be.

The lonely eminence of this image among its companion works is reflective of a wider dearth. One of the chief paradoxes of photography is that though it seems to be uniquely empowered to function as a medium of realism, it does so only rarely and under special circumstances, often behaving as if reality were something to be avoided at all costs. If "the camera can't lie," neither is it inclined to tell the truth, since it can reflect only the usually ambiguous, and sometimes outright deceitful, surface of reality. The history of the medium is the history of its practitioners' struggle to overcome this disinclination, to provide the missing sense of verisimilitude, to bridge the abyss between the viewer's innocent expectations—aroused by his belief in the authority and authenticity of what a photograph shows—and the camera's stubborn refusal to fulfill them.

Photojournalism supplied the deficiency by resorting to written texts and captions; the great picture stories in *Life* and *Look* were actually picture-and-word stories—collaborations between a photographer and a writer, in which each seemed to be compensating for the other's lacks: the photographer's inability to show, the writer's inability to describe. Art photography represents a more subtle collaboration—one between the photographer and the works of painting, drawing, or sculpture he has seen. During this century, the mesh between the two became ever more subtle as the overtly painterly works of the Photo-Secession gave way to the more photographic-*looking* but no less pictorial works of such modern masters as Strand, Weston, Kertész, Cartier-Bresson, and Evans. Cartier-Bresson's well-known phrase "the decisive moment" refers to the quest of the photographer, stalking the streets and countryside—like a hunting cat, as Cartier-Bresson has characterized himself when at work—for those brief instants when chance arranges people and objects into the meaningful patterns of paintings. (In photographic portraiture, the "moment" sought is the one

42. HENRI CARTIER-BRESSON, *Sunday on the Banks of the Marne*, 1939.

when the sitter's attitude and expression most closely accord with the attitude of relaxation and the expression of contemplation that are the conventions of portraiture in Western painting.) Scratch a great photograph and find a painting (or painterly influence): Cartier-Bresson's picnic on the banks of the Marne [42] derives from Manet's "Boating" [43]; Stieglitz's "Steerage" was (as he reported) inspired by Rembrandt; Arbus's photographs of freaks and drag queens are characters out of Pascin and Grosz; Sander's portraits of universal "types" arose (as Richard Pommer pointed out in *Art in America*) from his association with the Cologne Progressive school of painting; and Strand's and Weston's abstractions are, of course, derivations from Cubist paintings and sculptures.

The heavy odds against finding the desired (and, as it were, ready-made) work of art in the mess and flux of life, as opposed to the serene orderliness of imagined reality, give a special tense dazzle and an atmosphere of tour de force to any

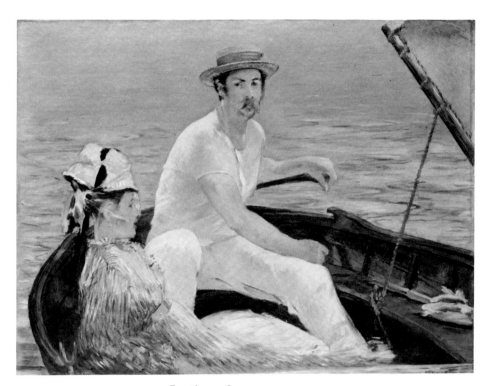

43. EDOUARD MANET, *Boating*, 1874.

photographs that succeed in the search. These odds are also what give photography its reputation (or former reputation) for being difficult—more difficult than painting, in the opinion of some commentators. In the early days of photography, photographers innocently thought they could get around the difficulty by posing, rather than looking for, their pictures, but they were soon disabused. One of the most notorious examples of this attempt is Henry Peach Robinson's composite photograph "Fading Away," a staged tableau showing a dying girl surrounded by grieving relatives [44]. The picture is as stiffly composed and as sentimentally conceived as any academic painting of its time (1858), but it succeeded only in annoying and offending the public, to whom it was evident that the whole thing was fraudulent—that the girl wasn't really dying, that the camera was trying to tell a lie. A less well-known but even more

44. HENRY PEACH ROBINSON, *Fading Away*, 1858.

atrocious instance of posed photography is Fred Holland Day's series (1898) depicting the last seven days of Christ, for which he himself posed after a year of strenuous dieting [45].

As this kind of photography was discredited and abandoned, so the photography of Strand, Weston, Kertész, and the others is being pushed aside by a rising new school of purists, who wish to free photography entirely from the shackles of art, and who are looking into the properties of the medium to see whether the "problems" of the old art photography may not be the strengths of the new, artless one—whether the elusiveness of photographic truth has not been the result of asking the camera to perform tasks it was not put on earth to perform. Theorists of the new school would argue, for example, that in the Robinson picture the camera was indeed telling the truth by showing up the patent falseness of the scene—that "Fading Away" constitutes nothing less than a triumph of the camera over the man who was trying to misuse it. Old and current snapshots are similarly being scrutinized and cherished for the

45. FRED HOLLAND DAY, *The Crucifixion*, 1898.

inadvertent truths they reveal, and the most advanced photographers are painfully unlearning the art lessons of the past and striving to create an aesthetic out of the ineptitudes and infelicities of amateur snapshooting. As a result, haphazardness, capriciousness, and incoherence are everywhere emerging as photography's most prominent characteristics.

If the camera can show up attempts to misrepresent reality (such as those of Robinson and Holland Day), it is just as ready to betray the photographer's intention of representing reality honestly. This capacity for betrayal is vividly illustrated in a collection of photographs called *Is Anyone Taking Any Notice?*, by the English photographer Donald McCullin, who is not of the avant-garde but belongs, rather, to the reportorial tradition of Jacob Riis, Lewis W. Hine, and the more recent "concerned photographers" Robert Capa, Werner Bischof, and David Seymour. McCullin travels around the world to scenes of war, famine, murder, torture, poverty, and disease (places like Biafra, Cyprus, Vietnam, Northern Ireland, and Bangladesh) with the object of taking photographs that "show how bad it is," and some of his pictures show it only too well. The pictures of starving Biafran children are examples of photography at its most direct, specific, and unbearable [46]. There is no gap here between intention and what is shown, nor, indeed, is any purpose served by McCullin's text. His question "Who needs great pictures when somebody's dying and he's only five years old?" has already been asked by the repulsive, emaciated, and bloated bodies and the beautiful faces of the children. A picture of a naked baby lying abandoned on a road and crying bitterly; a picture of a woman attached to an intravenous apparatus as she lies on a rag on a metal cot with no mattress (captioned "This Is a Hospital"); and a picture of a woman hopelessly nursing a baby from a completely withered breast are other images before which "great pictures" indeed pale—images that testify to the conscience-awakening powers of documentary photography. (One recalls in this connection the famous picture from the Vietnam war of the naked child running down a road after a napalm attack—a picture that may have done more to

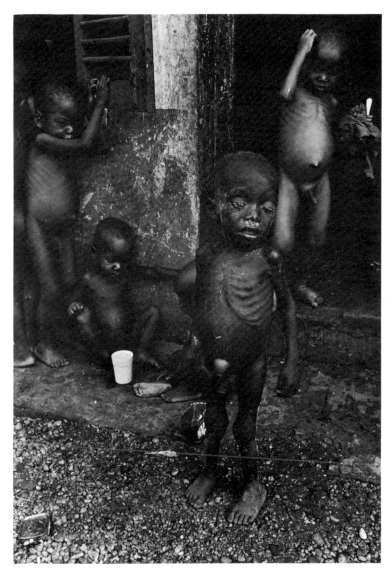

46. DONALD MC CULLIN, *Biafra*.

turn public opinion against the war than any other piece of anti-war propaganda.)

But other of McCullin's images perversely fail to fulfill the photographer's intentions. A photograph taken in Cyprus, for

47. DONALD MC CULLIN, *Biafra*.

example, depicting a scene of murder—two dead men lying on the floor, the head of one in a pool of blood, horrified spectators standing in the doorway—utterly fails to convince; it looks as staged as Robinson's death scene (or, more precisely, it looks like one of Duane Michals's staged surrealistic tableaux). Only after reading the photographer's text—"The room was warm with the smell of blood. I was really scared and tried not to look at their faces. I tried not to tread in the blood"—does it occur to the viewer that the men are really dead, that they have just died, that he is looking at something that actually happened. A close-up of a gruesome corpse [47] similarly defeats the photographer's purpose of expressing the horror and nausea he felt on coming across it: the camera here commits the indecency of playing with the abstract patterns that injury and putrefaction have etched into the face and body of what once was a man and now, set against background forms of debris and machinery, resembles one of the textural studies of Brassaï or Aaron Siskind [48].

48. AARON SISKIND, *Martha's Vineyard (The Tree 15)*, 1971.

In Henry James' *The Wings of the Dove*, Kate Croy makes a memorable distinction as she muses on the character of her scoundrel father and realizes that "the inconvenience—as always happens in such cases—was not that you minded what was false, but that you missed what was true." This same "inconvenience" is built into photography. As time goes by and millions upon billions of photographs are cast into the world like so many blurred, hasty, and partial, if not false, impressions, one's confidence diminishes in the seeing-is-believing claims of photography, and one's suspicion grows to a near-certainty that the camera is no better equipped than the eye to tell us what we want to know about the world.

1976

49. WILLIAM EGGLESTON, *Memphis, Tennessee.*

(All of the Eggleston photographs reproduced in this essay were originally in color.)

Color

PERHAPS NO STRONGER—or more ludicrous—demonstration of photography's mimetic relationship to painting exists than its recent appropriation of Photo-Realist art. The color snapshots of campers and frozen-custard stands and tract houses that the Photo-Realist painters took, blew up, and painstakingly rendered in oil or acrylic are now being retaken by avant-garde photographers and—without further ado, sometimes still dripping with the Polaroid fluid—rushed to the avant-garde galleries. Official sanction for this new school of photography came from the Museum of Modern Art in the spring of 1976, when John Szarkowski mounted a large show of color photographs by a young photographer from Memphis named William Eggleston, and simultaneously published in hard cover a long critical essay, illustrated with forty-eight color plates, entitled *William Eggleston's Guide*. Stephen Shore, another young photo-Photo-Realist, received a show at the museum a few months later, and scores of other photographers of this school have subsequently appeared at Light, Sonnabend, Castelli Uptown, and elsewhere. Color photography, which up to now had been associated with photography's most retrograde applications—advertising, fashion, *National Geographic*-type travel pictures, nature pictures, old-fashioned arty abstractions of peeling walls and European traffic signs—suddenly became the medium's most advanced form of all.

However, because one of the unwritten laws of contemporary photography is that no photographer shall ever publicly

admit to any painterly influence (Cartier-Bresson once laughingly confided that he coined the term "photojournalism" as a kind of diversionary tactic—a screen behind which he could do his painting-derived work and have no one bother him), there has been no acknowledgment anywhere of Photo-Realism as the progenitor of the new color photography. In his *Guide* essay, Szarkowski himself omits any embarrassing mention of Photo-Realism, merely grudgingly citing "modern painting" as one among many possible influences on the new color photographers. The chief difference between them and their predecessors, according to Szarkowski, is that they have "a more confident, more natural, and yet more ambitious spirit, working not as though color were a separate issue, a problem to be solved in isolation (not thinking of color as photographers seventy years ago thought of composition), but rather as though the world itself existed in color, as though the blue and the sky *were* one thing."

Szarkowski's conceit takes one back to the pre-color days, when the chief difference between the untrained snapshooter and the professional or good amateur photographer was precisely that the former took pictures "as though the world existed in color," while the latter knew better. Indeed, the whole art of black-and-white photography is the art of previsualizing black-and-white pictures, plucking them like rare flowers from an unphotographable landscape. One rejects most of what one sees through the lens, because one has learned to resist the blandishments of one's color vision. (It is surely no accident that stone and marble façades, Caucasian faces and bodies, snow, sand, and other black-and-white "naturals" figure very heavily among the masterpieces of black-and-white photography.) One anticipates that the most interesting and beautiful of *seen* images will be dull, flat, chaotic, messy, and undifferentiated when subjected to the levelling process of monochrome printing. Color film provided the snapshooter with what he lacked and had been limping along without, since color photography is always interesting to look at, whereas black-and-white is interesting only under special conditions. Thus, paradoxically, it is black-and-white photography that

demands of the photographer close attention to the world in color, while color photography permits him to forget it. The traditional separation by color of the serious photographer from the frivolous snapshooter represents the recognition on both sides that one medium is hard and the other easy—that one requires art and the other doesn't.

If color photography can do without art, this has not prevented cinematographers and photographers from attempting art in color, and, like their black-and-white predecessors, they have naturally gone to painting for their models. Films of obvious painterliness, such as *Elvira Madigan*, *Bonnie and Clyde*, *Last Tango in Paris*, and *Providence*, come to mind; their various derivations from Impressionism, Expressionism, Surrealism, and Abstract Expressionism are plainly visible. Color photographs by Steichen, Penn, Hiro, and Brassaï, among others, reflect similar painterly influences. But when Szarkowski epigrammatically observes of such color pictures, "It is their unhappy fate to remind us of something similar but better," he again has things by the wrong handle, since *all* art photography —black-and-white as ineluctably as color—shares this fate. It is one of the medium's occupational hazards; if a photographer wants to create rather than imitate, he should get himself a brush.

If, then, photography is the (uppity) housemaid of painting (as journalism and criticism are the poor relations of poetry and fiction), where does that leave Photo-Realist photography —photographs based on paintings based on photographs? Aren't *they*, at least, exempt from invidious comparison with their painting sources? No, not even they. Even here, painting maddeningly upstages photography—and does it by sheer size. The World Trade Center dimensions of Photo-Realist paintings (with a few medium-sized exceptions), like those of their Abstract Expressionist and Pop predecessors, are integral to their structure and signature. The experience of walking into a gallery and suddenly confronting one of these colossal blow-ups on the wall—one's shock, confusion, and indecision about whether to laugh, sneer, or marvel at this idiotic rendering of Kodacolor banality—is part of the style of Photo-Realism. (One

could characterize Photo-Realism as a kind of reverse Action painting: it lies inert and dormant, waiting to be "acted on" by the spectator.) The Photo-Realist photographer, with his puny eight-by-ten or eleven-by-fourteen prints, commands no such response. His pictures look insignificant, dull, even tacky, on the wall. The Eggleston photographs made a particularly poor showing in exhibition. They looked inartistic, unmodern, out of place in an art museum; an atmosphere of slouching dejection and tentativeness hung over them, which the reviews of the show cruelly confirmed. The Eggleston book is something else. The cover picture, which one scarcely noticed in the show, comes into its own. At first, careless glance, one might take it to be of a motorcycle sleekly poised for action, about to roar and soar away from the background of a stolid ranch house in whose carport a car is securely nestled; a second look reveals the puissant machine to be a mere kid's tricycle. Eggleston has approached his subject from below and invested it with preternatural size, weight, and defiance of gravity; the picture is an ironic salute to the power of photographic untruth as well as an almost tenderly lyrical portrait of a tricycle [49]. The glossy color picture is pasted on the reticulated dull-black imitation leather of the book cover above a line of stamped-gold lettering, and, thus framed—with an abstract interplay between cover and picture—it acquires a quality of modern art that entirely eluded it in the museum. (A number of subsequent avant-garde color photographers, alive to the problem of their works' inartistic, even kitschy, appearance on the wall, have tried various remedial expedients; Jan Groover, for example, does serial pictures, putting three slightly different close-up views of the same suburban house or stretch of highway side by side within one frame, and thereby achieves a pleasing abstract artfulness that the single view would not have yielded.)

The intimation of Eggleston's cover picture that his *Guide* will take us deep into Photo-Realist country is confirmed by the first photograph inside. (Photo-Realist country—as well marked as Impressionist country or Dutch-genre land—is defined by the presence of recently made structures, machines, and objects; by people dressed in clothes of the cheap, syn-

50. WILLIAM EGGLESTON, *Tallahatchie County, Mississippi.*

thetic, democratic sort; by the signs and the leavings of fast
food, fast gas, fast obsolescence; by the inclusion of the very
parts of the landscape that photographers used to try to elimi-
nate, edging the bridal couple away from the parked cars,
angling the lens to exclude the Laundromat sign encroaching
on the quiet tree-lined street. Such props have become the
Cézanne apples, the Monet poppies, the Cassatt white dresses
of Photo-Realism.) This initial picture, which is like an invoca-
tion to the muse of the genre, shows a neatly painted front door
on which a small, neat wicker basket, filled with blue plastic
flowers, is hanging—a picture simple almost to the point of
simplemindedness, and as rich and subtle as a haiku. One
knows perfectly well what lies behind that door: the "tradi-
tional" furniture of wood-grained plastic, the little ornate bon-
bon dishes with scalloped edges, the candleholders trimmed
with more, probably "autumnal," plastic flowers, the pinch-
pleated draperies of shimmering acrylic, the utter absence of
any mess or sign of life, or even of any trace of the puzzled
people who live there, caught between the church-picnic past
and the post-Dachau present. A few pages later, we find the
interior itself—a living room of mortuary immaculateness, con-

51. WILLIAM EGGLESTON, *Sumner, Mississippi.*

taining a bridge table laid out for the completion of a wild-bird round jigsaw puzzle [50]. Farther on, we move into the dining room and partake of a genteelly wholesome meal from gold-edged china set on pale-green patterned placemats: a slice of ham and a helping of over-cooked green beans; various side dishes of rolls, butter, baked potato; salad drenched with "French" dressing; and a glass of iced tea [51]. The rooms are in different houses, but the household gods are the same; similarly, the *Guide* tours the country around Memphis but evokes anywhere in America in the nineteen-seventies.

In his best work, Eggleston seamlessly yokes Photo-Realist irony to photographic immediacy—to the now-or-never *once-ness* of a gesture, a posture, a quality of the light, the presence of a shadow. One such work is a picture of a stretch of dirt road near Glendora, Mississippi [52], taken on a clear, windy summer day: one of those heart-catchingly lucid days of blue sky and fast-moving clouds, of juicy, fragrant greenness, of shivering tree leaves showing their white undersides—a day that looks, one says to oneself, like a Kodacolor snapshot, but that, conversely, a Kodacolor snapshot never evokes. The evocativeness of *this* Kodacolor picture is elicited by the alien presence

52. WILLIAM EGGLESTON, *Black Bayou Plantation, near Glendora, Mississippi.*

of a dozen white plastic bottles scattered along the road by the breeze, which has also pushed around a couple of corrugated-paper cartons. If one puts one's hand over the lower part of the photograph, thus eliminating the bottles and boxes, one is left with one of those landscapes of utter dullness and pointlessness that one is always being sucked into photographing while travelling through pretty country; with the foreground debris, the photograph acquires a Proustian reverberation—as if the adventitious were needed to "set" the familiar and universal, were the broth in which the germ of memory can breed. We feel that we have been there, on that day, along that piece of road, with those clouds and those plastic bottles.

Another remarkable picture—remarkable in a different way—is of a lean older woman sitting in the center of a dilapidated outdoor chaise on a day at the end of summer [53]. It is a color picture about color photography. The woman is sitting on and against cushions printed with a riotous pattern of yellow and orange and green flowers; her dress is another bold floral print, in magenta, blue, and red; above her head is a pattern of sun-dappled green leaves seen through the grid of a white lat-

53. WILLIAM EGGLESTON, *Jackson, Mississippi.*

tice; and, finally, at her feet is yet another pattern, of dead leaves on flagstone. In black-and-white, these patterns—and, so to speak, the woman, the chaise, the leaves, the flagstone—would cease to exist. In other memorable pictures, an atmosphere of romantic melancholy wafts out of their commonplace subject matter: a crepuscular view of a street in Memphis, in which telegraph wires and dark trees hover mournfully over a littered embankment and gutter; a sad view, also photographed at dusk, of a deserted swimming pool seen through the mesh of a fence. A picture of a man sitting on the edge of his bed in a motel in Huntsville, Alabama, speaks of every motel one has ever been in; one can almost smell the cloying disinfectant, see the paper band over the toilet seat, feel the man's nervous loneliness. Among pictures of a more abstract and yet still firmly realist character, there is one of a child's half-inside-out snow jacket hanging on the wall over a crib (cropped to show just the edge of the crib) [54], a peering view of an oven interior, and one of a green-tiled shower stall.

Last year, Eggleston travelled to New York from Memphis to appear in a symposium on color photography at the International Center of Photography. He was wearing a beautiful dark

54. WILLIAM
EGGLESTON, *Near
Jackson, Mississippi.*

suit (in contrast to the casual dress of the other panel members),
and when it came his turn to speak he was so overcome by
shyness that he was unable to get out more than a few almost
inaudible, red-faced monosyllables. The audience and the
panel were sympathetic to his plight at first, but as the evening
wore on, and Eggleston steadfastly failed to answer questions,
the gathering turned against him, and people began to needle
him. It was as if his suffering muteness was intentional—was
a judgment on the glib vacuity of the symposium. (Question:
What are you trying to say with your photographs? Answer:
Well, let's put it that I'm a formalist. Let's put it that I'm looking
for forms. Etc., etc.) Eggleston's alien presence transformed a
boring and banal occasion into a painful and strange one—one
that sticks in the mind, and, like Eggleston's photography (like
all true photography?), does so because it doesn't quite add up.

1977

55. RICHARD AVEDON, *Dovima with Elephants*, 1955.

A Series of
Proposals

THE RICHARD AVEDON EXHIBITION at the Metropolitan Museum is hung in a long internal corridor that has been broken up into five "rooms," each representing a period in the photographer's thirty-year career in fashion photography. About midway through the show, one realizes that one is witnessing (undergoing) a kind of Alice in Wonderland drama of growth: the pictures are getting bigger and bigger. In the first room, they were small, numerous, uniformly framed, hung in serried rows; by the last room, there are only seven supercolossal portraits, dwarfing the viewer. The device, which rescues the show from the stasis and tedium common to shows of prints of conventional, uniform size, is also a piece of subtle and ambiguous self-evaluation. On one level, the progression from small to big mockingly traces the photographer's rise from modest beginnings as an eager young toiler at *Harper's Bazaar* to his current status as the biggest and richest and most celebrated fashion photographer in our galaxy. On another level, and quite seriously, it expresses Avedon's sense of himself as an expanding artistic consciousness. Finally, it is a kind of meta-statement about the almost monstrous complexity of Avedon's late vision of his art.

Concurrent with the drama of enlargement is the drama of Avedon's changing relationship with the medium of fashion

photography: each room reflects a different attitude. Fashion photography can be likened to some of the more inflexibly formal poetic modes, such as the villanelle and the sestina. The fashion photographer's givens of dress, model, and magazine format are comparable to the villanelle's procrustean rhymes, the sestina's ineluctable endings. The task is to do it correctly but not show the strain; rare masterpieces do not even reveal the form at first reading or viewing. Avedon's earliest fashion pictures reflect the tension and joy of the gifted beginner in love with the form and not yet sure, deep down, that he can do it. Consequently, each early picture has about it a kind of shimmer of extra-ness, like that of an A paper crying out for an A-plus because so much more was done than was required. When Avedon entered fashion photography, after the Second World War (he had learned the rudiments of photography in the merchant marine), it had just passed through a Great Period, whose masters—Dahl-Wolfe, Hoyningen-Huené, Munkacsi, Steichen, Beaton—have yet to be surpassed. The pictures that Avedon took in Paris for *Harper's Bazaar* between 1947 and 1957 are at once a serene celebration of the conventions of the master fashion photographs of the thirties and an anxious quest for new metaphors. His shrewd recognition of the fact that to join the ranks of the masters he must do more than imitate them drove him to lengths of artifice that fashion photography had hitherto not seen. These ruses and tricks were so persuasive, the inventions and ideas so ingenious, that to this day Avedon's reputation for naturalness and spontaneity is undimmed. His photograph, for example, of a model in a Balenciaga suit on a Paris street watching a group of acrobats (hired by Avedon) was accepted—and presumably continues to be accepted—for what it could not possibly be: an amusing, careless romp through the streets of Paris, with an adventitious encounter. Another memorable example of Avedon's youthful illusionism is a picture in a Paris bar of the models Suzy Parker and China Machado dressed in lovely long, slinky evening gowns, languorously posed (Machado holds a placid white Persian cat), and escorted by handsome, bored, oversolicitous young men

in evening clothes. This utterly improbable scene of glamour and money and romance is made believable by the quiet (and, of course, hired) presence at the end of the bar of two old Frenchmen of the sort one does see in French bars, who take the picture out of the realm of fashion-model unreality and triviality and ground it in real life. They impart credibility to the incredible, authenticity to the spurious.

The culminating photograph of this first decade of Avedon's career (which occupies the first two rooms of the exhibition and breaks up loosely into the initial we-try-harder period and an easier and more assured later period) is of the delicately beautiful model Dovima in a long black evening dress, her head in uptilted profile, one hip thrust to the side, a small satin-slippered foot pointing forward, and one hand gently resting on the upward-coiling trunk of an elephant that is walking toward the viewer, while the other hand is held out in an imperious, straight-armed gesture of dismissal, which a second elephant seems to be heeding as he walks out of the picture [55]. (Closer inspection reveals that both elephants are chained to the ground.) If this high-spirited piece of audacity pokes fun at fashion photography ("What a preposterous business this is!" the picture says. "Look where the quest for the new, the startling, the outré can lead!"), it also brilliantly fulfills its dictates. The magical and funny picture is, above all, a great fashion photograph. What better way to sell a dress than to set its elegant sleekness of line and expensive smoothness of texture against the rough, wrinkled hides and ponderous shapes of elephants? It is instructive to compare this picture with what may have been its inspiration: Edward Steichen's celebrated *Vogue* photograph of 1935, for which he brought a white horse into a white-tiled lavatory and posed three models in white clothes around it—a notion that comes out looking as ridiculous as it sounds [56]. Why Avedon's even more outrageous idea works when Steichen's doesn't could sustain a course in fashion photography. Part of the answer lies in a kind of laxness of Steichen's imagination—a reluctance or inability to really carry through what he had undertaken. Instead of going with

56. EDWARD STEICHEN, *White*, 1935.

his white horse, as Avedon went with his elephants, Steichen stops short. The elements of his picture never mesh, as those of Avedon's do—the models remain separate from the props. The central model, who is gingerly patting the horse's neck and is wearing a kind of Mexican-hayride pants suit and a straw hat, may be the chief culprit: if she were removed (which would leave a white horse docilely standing in a men's room, flanked by two women in Grecian-style evening dresses), the picture would lose a lot of its silliness, and might even begin to partake of the surrealism that the Avedon picture so triumphantly exhibits, along with its satire. Although you "know" that the elephant picture is a posed fashion photograph, on another level you don't know. You simply accept, as you accept the impossible events in a Rousseau.

The third room, representing work of the early sixties, is joltingly different from the previous ones. If the elephant seemed to have brought Avedon to the edge of something, he has now clearly gone over. He is no longer valiantly tussling with the confines of the medium, using them (as poets use regular rhyme and metre) to plumb his unconscious and shape his invention. In fact, he is no longer playing the game. Having won it, he petulantly pushes over the pieces. Having mastered the art of fashion photography, he proceeds to savage it. He becomes an anti-fashion photographer. Avedon's portrait work comes in here. From the start, in addition to the fashion pictures, he made portraits for *Harper's Bazaar* of celebrities, which were of a piece with his fashion work. As the fashion pictures celebrated the beauty and desirability of the models and their clothes and hair and makeup, so the portraits celebrated the famousness and specialness of their subjects. They had all the gaiety, charm, originality, appreciativeness of the fashion pictures; their particular Avedonesque vivacity was always at the service of the subjects' amour propre. All this changed in the late fifties and early sixties. Avedon's portraits no longer humbly accepted the idea of a person's famousness and specialness. They cut him down to size. Somerset Maugham was shown in all his wicked-old-man ugliness and wrinkled jowliness; Dorothy Parker was portrayed as an anguished alcoholic; Dwight Eisenhower looked like a mental defective. These portraits were a judgment on people; they were sharp, black, inky, nasty. And the fashion pictures of this same period are a judgment on fashion. They are stylized, strident, brutal, bitter. There are no more backgrounds. The models who exuberantly ran down the Champs-Élysées now prance and leer in the white void of Avedon's studio and don't even pretend to be doing anything but making money or, in the case of the celebrities who then began lending themselves to fashion pictures, getting free publicity. Cynicism and hardness pervade the frenetic, unpleasant pictures of this third room. One of the most chilling of them looks like a triple-mirror image of a running, gesticulating, falsely smiling woman dressed in a plaid suit and a turban; it turns

out to be a picture of three *different* women, wearing the same dress and turban and smile. Avedon has taken the fabled awful moment when you come to a party and someone is wearing your dress, and contemptuously shrugged: "What's the difference? The clothes are all alike. The women are all alike. It simply isn't interesting." He makes the same brutal point with a series of elegantly stylized portraits of socialites dressed in black—Dolores Guinness, Antonella Agnelli, Princess Elizabeth of Yugoslavia, among others. These portraits are immensely flattering (Avedon's lighting here produces a chiaroscuro effect and a flat white perfection of skin tone, and the subjects are posed so as to give their necks a lovely, swanlike elongation) and—here's the kicker—practically indistinguishable from one another. An even more misanthropic note is struck in the pictures where Avedon has brought crowds of "real" people to the studio to serve as background for fashion models. Unlike the attractive, characterful Parisians of the early pictures, these supers (the personnel of the house of Dior [57], members of the French press, for example) are of unvarying unattractiveness—fatness or scrawniness, slack-jawed dullness, pitiful agedness. Avedon has, of course, created them with his pitilessly scrutinizing strobe lights and mole-into-mountain-making big camera, to whose grim transformations only young children and specially endowed adults, like fashion models and Picasso, are impervious. The models in these pictures look like a different species: they stand out from the background people as Dovima stood out from the elephants. Only here, the idea is not to bring the models' beauty into relief but to point up its artificiality and vapid unreality. The idea works so well it's a wonder that the "real" people didn't sue Avedon, and that his employers didn't fire him.

The wisdom of sticking with this aging *enfant terrible* is confirmed in the next room. In the late sixties, evidently refreshed by his bout of bad temper and caddishness, Avedon sets up the pieces again, and commences to play the game with a brilliance and an inventiveness that surpass even his own early achievement. The dazzling motion studies of this period

57. RICHARD AVEDON, *House of Dior,* 1961.

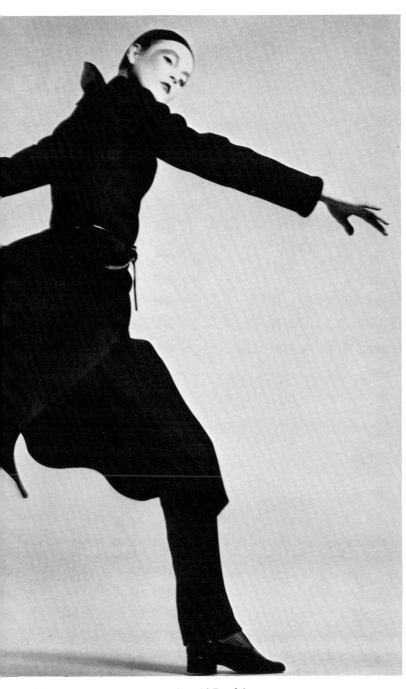

58. RICHARD AVEDON, *Ingrid Boulting*, 1970.

bring to mind the distortion nudes of André Kertész. Avedon
takes the materials of a fashion assignment—model, dress,
hairdo, shoes—and creates abstractions from them that bring
something new to photography. Neither the illusion of the first
period nor the disillusion of the second is present in these
photographs: they are "about" nothing but themselves. (At the
same time, they are touched with the zestful energy of the early
work. They reverberate with the vigor of the photographer's
attack on the problem he has set himself; they have the serious-
ness of a child at play.) Avedon's years of putting clothes on
models and observing what happens when they move—his
long enforced preoccupation with the relationship of body and
garment—were a preparation for these eloquent studies of flesh
and bone and muscle and fabric in motion. They are a kind of
dance photography, and, perhaps precisely because they are
not pictures of real dancers doing real dances, they come closer
than any other photographs have come to solving the impossi-
ble, *koan*-like problem of the genre: how to show movement in
a *still* medium, how to describe motion by arresting it. Avedon
has the advantage of the metaphorical approach, and he makes
the most of it. His enormous photograph of the model Ingrid
Boulting—wearing a long, fitted black Dior coat and narrow
black trousers, her hair sleeked close to her elegant small head,
her face powdered white and strangely made up to resemble a
Kabuki actor's, her body tautly twisted, her arms stretched out-
ward in rigid, stylized grace, one foot upraised like an ice
skater's—is like a moment out of some marvellous exotic enter-
tainment in an imaginary Tartar kingdom, a dance of stiff fluid-
ity, of stately movement alternating with stasis, accompanied
by the whining insinuation of Oriental wind instruments [58].
The moment is at once captured and "set" in a powerful
abstract design, reminiscent of a Toulouse-Lautrec poster in its
bold deployment of large black forms. Another remarkable
work of this period shows (or, rather, obliterates) the model
Jean Shrimpton in a swirling long gown of gossamer translu-
cency, whose large pleated collar has flown up over her head
and turned her into a kind of Winged Victory; evocative, too,

of classical Greek sculpture is the straining thrust of body through fabric, the intricate complexities of fabric that variously cleaves, molds, falls in folds, and trails.

In addition to the motion studies and some Westonesque still abstractions (a foot encased in an archaic gold slipper with a wool tassel; a torso in an unbuttoned black beach garment showing a gleaming upturned breast), the fourth room offers a number of large, handsome portraits of young countercultural celebrities like Joan Baez and Janis Joplin. These idealized blowups—a reversion to the romanticism of Avedon's earliest period—cast light on the idolatry of youth which middle-aged liberals were seized by during the Vietnam years. They are social documents of a sort: a hundred years from now, someone may want to know what the term "radical chic" meant, and these pictures will tell him.

Entering the final room, one feels the kind of abrupt hush that a cathedral imposes on the person entering its awesome vaulted vastness from the small-scale bustle of the street. The room is hung with seven colossal portraits of women, nine feet high and six feet across, which flap loose from the walls, too large to fit a frame. The subjects are of varying ages and physical types, and—with one exception, the writer Renata Adler—are unknown. They are photographed in the "straight," direct, daylit, passport-photo style that Avedon exhibited at the Marlborough Gallery in 1975 and published the following year in his book *Portraits*. Viewers—who are not only dwarfed by the photographs but reduced to the blurred uninterestingness of contact prints by the particularity of their sharp definition—stand before them as before an enigma. What do these portraits "mean"? What are they doing in a show of fashion photographs? Is Avedon once again recoiling from the meretriciousness of fashion, meanly contrasting the vacuousness of fashion-model attractiveness with the deep human beauty of "real" women? Yes, of course he is doing that—but he is doing something else as well. The anonymity of the portraits offers a clue to their fuller meaning. These pictures of women we don't know invite us to read them, to make up stories about them.

An aura of the allegorical wafts out of them, as if each woman represented an age and stage and manner of life. Into Priscilla Rattazzi, a young girl in a white shirt and jeans, we may read the unripeness, softness, self-absorption, self-consciousness, moodiness, conventionality, good-heartedness, pessimism, and tentativeness of adolescence [59]. The portrait of Renata Adler was taken in the French West Indies, and its sun-struck aspect turns one's mind to the novels of Conrad, suggests exquisite Conradian moral dilemmas for the boyishly slender young woman with tragic eyes and proud mouth and long cast-away braid. The portrait of June Leaf shows a woman in early middle age, with a face shaped by good bones and the good lines of a fully lived and examined life, her crossed arms hugging her chest in an affecting gesture of self-protection. In a book of the show currently published by Farrar, Straus & Giroux, where the pictures are differently and less effectively organized, there is a didactic juxtaposition of this photograph with one of Marella Agnelli made in 1953, instructing the reader in the difference between artificial and natural beauty—between the smooth, opaque, doll's face, the hairdresser-dressed hair, the Old Master portrait lighting, and the aristocratic formality of the one and the expressive worn features, the proletarian shirt, the uncombed graying hair, the sagging bosom, and the unretouched vitality of the other. However, in not being able to indicate the size of the Leaf portrait the book misrepresents it, in the way that book reproductions of large paintings misrepresent them. The size of these portraits is not incidental but intrinsic—an essential stylistic property. The portrait of Loulou de la Falaise illustrates with special lucidity the significance of scale in Avedon's recent portraits. The subject looks like an escapee from the Warhol Factory, with her punk outfit of gleaming black leather jacket, baggy trousers and shirt, rhinestone earrings, dark makeup, and mordant Marlene Dietrich smile. One is not altogether sure that this person is a woman. What "she" may be smiling about may be the success of "her" impersonation. What the picture itself mocks is the labor and pretensions of Photo-Realist painting. Here, just by

59. RICHARD AVEDON, *Priscilla Rattazzi, 1977.*

squeezing the bulb of a big camera and spending a few
hundred bucks at Modernage, Avedon can do in a day what it
would take a painter months to achieve. The sort of demented
attention to detail that, along with (and deriving from) its enor-
mous scale, is Photo-Realism's signature is present in this pic-

ture—but only to a slightly higher degree than in the others. This whole late style of portraiture, with its built-in intention of gallery exhibition, represents Avedon's flight from the confines of fashion-magazine photography to the larger spaces and ambitions of the art world—Photo-Realism having provided both the sanction and a satiric occasion.

Avedon's chef-d'œuvre of irony, however, is reserved for photographers and photography. To photographers he says, in effect, "You, too, can click the shutter and hire the technicians. If you do exactly as I have done, you will get pictures exactly like mine. Any woman on the street, when treated as I have treated the women in my portraits, will bristle with meaning and interest, will become allegorical and archetypal, will make a statement about the condition of woman and of humanity. There's nothing to it." Avedon strips away photography's pretension to being an art and a craft, saying that it is nothing but an idea, a series of proposals about picture-taking. The show at the Met illustrates this idea of photography as a *mental* medium, more like math and chess than like painting and drawing, and triumphantly "proves" it. The Marlborough show of 1975 obscured the idea by being a show of pictures of famous people. Viewers came to see what Edmund Wilson, Truman Capote, Jasper Johns, William Buckley, George Meany, or Willem de Kooning looked like in a photograph by Avedon, and came away puzzled and antagonized by the intransigent directness of the photographs. The October 21, 1976, issue of *Rolling Stone*, in which Avedon published seventy-three portraits of American politicians and other influential people who were concerned with the election, rectified and clarified the problem of the Marlborough show. A tabloid paper is where pictures of politicians (and literary and art celebrities) belong —people to whom the viewer brings preconceptions, expectations, and emotions that cannot be erased, and whose likeness consequently cannot be "used" as a vehicle for conveying a large statement about humanity. The blurred grayness of newsprint proved to be a felicity rather than a detraction: by mitigating the super-realistic sharpness and blackness of the prints,

it made the portraits more lifelike, more like what the eye sees. Many of the portraits (Ted Kennedy, George McGovern, Ralph Nader, Daniel Patrick Moynihan, Hubert Humphrey, Henry Kissinger, Nelson Rockefeller, to cite a few outstanding ones) were of unforgettable poignancy and psychological truthfulness. With the Met portraits, Avedon continues the work that commenced with the great, unbearable studies of his dying father (shown at MOMA in 1974), about which there is "nothing personal" (to borrow the telling title of Avedon's second collection of photographs), and in whose implacable objectivity lies a description of photography as well as of our common fate.

1978

60. BILL OWENS, *Untitled*, 1972.

Two Roads, One Destination

Realistic, illusionist art had dissembled the medium, using art to conceal art. Modernism used art to call attention to art. The limitations that constitute the medium of painting—the flat surface, the shape of the support, the properties of pigment—were treated by the Old Masters as negative factors that could be acknowledged only implicitly or indirectly. Modernist painting has come to regard these same limitations as positive factors that are to be acknowledged openly. Manet's paintings became the first modernist ones by virtue of the frankness with which they declared the surfaces on which they were painted. The Impressionists, in Manet's wake, abjured underpainting and glazing, to leave the eye under no doubt as to the fact that the colors used were made of real paint that came from pots or tubes. . . .

Whereas one tends to see what is in an Old Master before seeing it as a picture, one sees a modernist painting as a picture first.—Clement Greenberg.

PHOTOGRAPHY WENT MODERNIST not, as has been supposed, when it began to imitate modern abstract art but when it began to study snapshots. The photographic properties that art photographers had been struggling to conceal or eradicate or mitigate since the invention of the camera—and that the photographic avant-garde, belatedly jumping into the mainstream of twentieth-century art, now celebrates—have been on

clear view for over half a century in the mammoth museum-without-walls of amateur and vernacular photography. In the artless relics of picnics past—in the images of squinting children, of faces distorted by eating or hollering, of badly fitting clothes, improbable gestures, impossible movements—the avant-garde photographer finds ready-made the self-reflexive style that the modernist painter had to invent. Robert Frank, the Manet of the New Photography, scrupulously shed all the pictorial values of his predecessors—composition, design, tonal balance, print quality—and produced pictures that look as if a kid had taken them while eating a Popsicle and then had had them developed and printed at the drugstore. In *The Americans*, Frank showed photography at its most nakedly photographic. Permitting the camera what no art photographer had ever hitherto let it get away with—all the accidents of light, the messy conjunctions of shape, the randomness of the framing, the disorderliness of the composition, the arbitrariness of gesture and expression, the blurriness and graininess of the printing—he showed America at its most depressing and pathetic. However, Frank has been overvalued as a social critic and undervalued as a photographic innovator, for what he revealed was something not about America but about photography. Taking his cue from the snapshot, he grasped that the camera is equipped as no other medium is to show us things in their worst possible aspect. The camera's profound misanthropy, its willingness to go to unpleasant places where no one wants to venture, its nasty preference for precisely those facets of our nature that we most wish to disown (one is reminded of the diabolical mirror in Hans Christian Andersen's story "The Snow Queen," in which "all good and great things became small and mean, while all bad things were magnified, and every flaw became apparent") are the real subjects of Frank's pictures. Frank was hardly the first person to point out that our consumer society is vacuous and chaotic, but he was the first photographer to make a virtue out of—indeed, erect a style on—the fundamentally vacuous and chaotic appearance of photography [61].

61. ROBERT FRANK, *Gallup, New Mexico*, 1955–56.

Followers of Frank continued the movement away from the meretriciously "beautiful" photographs of the past. Simply by

going with the camera instead of against it, they produced a body of work that looked as different from the photography of the past as Action Painting did from its predecessors. That this photography emerged shortly after the emergence of Action Painting is itself yet another indication of the close (if often secret) watch that photography keeps on developments in painting. Garry Winogrand's formulation "I photograph to see what something will look like photographed" surely derives from the moment in art when, as Harold Rosenberg analyzed it, "the canvas began to appear to one American painter after another as an arena in which to act—rather than as a space in which to reproduce, redesign, analyze, or 'express' an object, actual or imagined." He continued, "What was to go on the canvas was not a picture but an event. The painter no longer approached his easel with an image in his mind; he went up to it with material in his hand to do something to that other piece of material in front of him. The image would be the result of this encounter." Thus Winogrand, Lee Friedlander, Emmet Gowin, Henry Wessel, Jr., Mark Cohen, Bill Owens [60] and other "action" photographers followed people on the street, peered into suburban living rooms, hung around fast-food chains, and—with nothing in mind, with none of the elaborate previsualizations of traditional art photography—repeatedly clicked the shutters of their small cameras. Later, scanning contact sheets, they selected their pictures—decided what the "decisive moment" had been.

The emergence of this school of photography just at the time when the medium was entering a period of unprecedented critical attention and commercial exploitation created a complicated situation. It drove certain photographers, critics, publishers, and collectors, who had hitherto serenely considered themselves aesthetically advanced, into an uncomfortably retrograde position. These were the people who had worked for the acceptance of photography as an artistic medium, denying its mechanical nature and stressing its affinities with traditional art. From their point of view, the messy pictures of Winogrand and the others were an affront: photography had finally proved

itself—was in its highest efflorescence of art and craftsmanship —and along come these guys to call the whole game off. What was even more galling to the traditionalists was that these radicals, these impudent prickers of photography's pretensions, became overnight stars of the art establishment. John Szarkowski's photography department at the Museum of Modern Art fawned over them, the Guggenheim Foundation showered grants on them like confetti, universities hired them, the Light Gallery provided a permanent *salon des acceptés*. The recognition that modernist painters and sculptors (not to say photographers) had had to fight for was picked up like a welfare check by the post-modernist photographer. At the same time, the traditional pictorial photograph (boring though it was to Szarkowski) became one of the hottest commodities on the art market. What the traditionalists lost in the academy they retrieved in the marketplace. Never in the history of photography have photographs sold as they have sold in the past decade—photographs of the past, that is, and of the Stieglitz-Strand-Weston-derived present. Pictures by the Winogrand school never sold, or even became known outside the academy. The single member of that school whose work is collected as art and whose reputation has extended beyond photographic circles is Diane Arbus, and the reason is that she doesn't really belong to the school at all. Arbus's first exhibition, at MOMA in 1967, in a group show with Winogrand and Friedlander, established a false connection. Her charm for the public is not in the intransigence of her images of anxiety and sordidness but in their painterliness. She was an old-fashioned photographer (her apprenticeship had been served on fashion magazines), using traditional forms to examine old existential dilemmas. The only "modern" thing about her pictures is that her freaks and drag queens and unhappy housewives and inmates of mental institutions happen to be living in our day. The style of her photographs is the composed, static style of the nineteenth century; many of Arbus's pictures could have been taken by Mrs. Julia Margaret Cameron. It is precisely the disparity between her pictures' orderly formalism and the messy chaos of what they

62. DIANE ARBUS, *Russian Midget Friends in a Living Room on 100th Street, New York City*, 1963.

show that creates their fascinating horror [62]. Photographers who have tried to follow and imitate Arbus have failed because they have not understood (and she herself was misleading about it) what she actually did. She is at once an anomaly and a bridge between the two camps that photography has polarized into.

Something unexpected is beginning to emerge from this polarization. As each side digs out its position—the avant-garde going deeper and deeper into its examination of the photographic, the old guard into the making of medium-transcending beautiful forms—the gap between them seems to be *narrowing* rather than widening. Two exhibitions in New York illustrated this paradox with special lucidity. One was a show

63. EVE SONNEMAN, *Sight/Sound: for Mike Goldberg, Samos, Greece*, 1977. *(Original photograph in color.)*

of color photographs by the young avant-gardist Eve Sonneman, at Castelli Uptown, and the other was a show, also of color work, by the renowned master formalist Harry Callahan, at the Light Gallery. Sonneman takes one of the most radical and mordant attitudes toward photography on record. By the simple device of showing pictures in pairs—two slightly different or vastly different views of the same subject, set in a single frame—she attacks what even the most belligerent of the Winogrand school accepted as a core concept; namely, that there is such a thing as *the* picture of something. With her pairings, Sonneman argues that there is only *a* picture—that any photograph taken is inevitably arbitrary. In a typical Sonneman pairing, Picture No. 1 shows an arrangement of objects on a red blanket spread out on the large gray pebbles of a Greek beach, including a panama hat, a pair of sunglasses, a Sony tape recorder, a Penguin paperback edition of Philostratus' *Life of Apollonius*, illustrated with a picture of a Greek nude male statue, and a copy of *The Selected Poems of Frank O'Hara*, illustrated with Larry Rivers's drawing of O'Hara, nude except for his black socks; Picture No. 2 shows the same blanket and objects and pebbles, except that they are a bit smaller, because the photographer has stepped back a little in order to include, at the top of the static photograph, an exciting glimpse of pounding surf [63]. This boring and fascinating pairing (which also touches on and mocks the portentous significance that

64. EVE SONNEMAN, *The Instant and the Moment, Greece,* 1977. *(Original photograph in color.)*

details assume under the camera's aimlessly scrutinizing eye) spells out the fundamental inability of the camera to tell the whole truth. If a painter wants to show large objects *and* surf, this can be arranged: he has only to get himself the right-size canvas. He is the monarch of all he surveys. The photographer, on the other hand, is the slave of his range finder. He has to make choices: he is always giving up something, he is always lying a little.

Another Sonneman pairing ponders another facet of photographic untruth. Picture No. 1 presents the Parthenon as every contemporary photographer is obliged to present it: as the backdrop for a satiric study of the jet-age tourist. The second picture (deviating from the majority of the pictures in the show) changes location and shows what appears to be a small provincial airline terminal. Officials and tourists are briskly walking in and out of the low, nondescript building [64]. It is a picture almost entirely without interest—something that might have been taken by a child trying out his new Instamatic as his mother tugs and drags him to the check-in counter. But then, suddenly, one sees something in the left-hand corner that causes one to sit up and take notice: a man is walking into the picture with his arms raised over his head, as if there were a gunman behind him. One realizes that the picture is about a hijacking. But is it? How can it be? Everyone else in the picture is going about his business calmly. But then why does the man

65. EVE SONNEMAN, *Pushing, Houston,* 1972. *(Original photograph in color).*

have his hands up? One concludes, finally, that it must be one of those accidents of photography—one of those "mistakes" the camera makes when it shows a tree growing out of a man's head or causes a person to look tragic when he is merely scratching his ear. In a third series, Picture No. 1 shows a man sitting at a table near an open window that looks out on a formal garden; he is reading a map, holding it up so that his face is obliterated. In Picture No. 2, the man himself is obliterated; the photographer has moved in to take a close-up of the window, but the light has changed (or Sonneman has changed her camera settings), so that the garden, though now dominant, is also recessive, because of the washed-out effect of overexposure. In a book of Sonneman's work in black-and-white called *Real Time,* there is a memorable series showing four people pushing a car [65]. In Picture No. 1, they are seen from one perspective and in No. 2 from another, while the car itself appears not to have moved. The second picture thwarts the viewer's expectation of forward movement; the movement it does show is in another direction and in another time—the photographer's, not the subject's.

The sense of paradox within the Sonneman pairs is accompanied by an external paradox: each member of the pair devaluates and discredits photographic values of the other, but together the two become something more than a critique of photography—they form *an object.* Singly, Sonneman's pic-

66. HARRY CALLAHAN, *Grasses in Snow, Detroit*, 1943.

tures are without interest; conjointly, they are respectable works of avant-garde art. Like conceptual works, earthworks, and other manifestations of what Rosenberg called "de-aestheticized art," the Sonneman works retain (gain) an aesthetic residue. They follow what seems to be an invariable principle of avant-garde art: if a critique of art (or even a statement of anti-art) is made honestly, fiercely, disinterestedly, and cleverly enough, it begins to partake of the appearance of art. Duchamp's found objects first established this peculiar principle. An equally peculiar corollary is that when imitators come along and cynically and mindlessly copy the original—sometimes without even grasping its intellectual point—the result still looks like art. Serial photography, accordingly, is becoming an avant-garde fashion.

Harry Callahan has produced some of the purest and most austere abstract photography of our time. His career is one of those monuments to dedication and work and care and belief in self that command respect even where they do not induce

67. HARRY CALLAHAN, *Eleanor, Aix-en-Provence*, 1958.

love. His spare abstractions of marsh grasses, telephone wires, and weeds in snow which look like nervous-lined modern drawings [66]; his photographs of architectural façades which look like Mondrians; his surrealistic superimposition of his wife's nude torso on grassy fields [67]; his abstract close-ups of

68. HARRY CALLAHAN, *Eleanor, Port Huron,* 1954.

the anxious faces of people on the streets of Chicago—all have
established his reputation in modern-art circles and reflect his
connection with the painterly tradition of photography. (An
even blunter example of an old-fashioned photographer mis-
taken for a modernist is Aaron Siskind, a colleague of Calla-
han's at the Rhode Island School of Design, who is believed to
be a photographic Action Painter. But the Kline-like and de
Kooning-like abstractions that Siskind extracts from graffiti-

covered walls and rubble-strewn gutters are created in a manner and spirit inimical to the manner and spirit of Action Painting. Their beauty and profundity derive from the sense of awe and humility they reflect: awe before the supremacy of painting, and humility before the difficulties of photographic craftsmanship—something very different from the arrogant self-involvement of the Action Painter. This said, it is necessary to introduce the muddying complication of a photograph, cited by Thomas Hess in his introduction to a book of Siskind's photographs, that looks like a de Kooning, was done before de Kooning painted like that, and is owned by de Kooning. Photography's mired relationship to painting is forever throwing up such chicken-or-egg dilemmas.) Callahan's photographs are stylistically of a piece, marked by a kind of exquisite dryness, a quietness and evenness of tone, and a quality of muted restraint, almost grudgingness. He is a sort of harpsichordist of the camera; with a few exceptions (one such [68] is a picture of his wife, Eleanor, lying nude on a towel in a landscape of sumacs), his pictures do not leap out at the viewer and demand attention. His work is hard to respond to, the way a quiet, drab-looking person at a party is hard to go up and talk to. In his introduction to a collection of Callahan's photographs, Szarkowski (after noting of Callahan personally that he is "a tongue-tied and defensive man of action, as tightly closed, when sober, as a good vault, except when photographing") expresses with acuteness and tact what it is about them that pushes one away:

> One of the distinctive characteristics of Callahan's work (some might say a limitation of it) is its consistent lack of vulgarity—using that word in a merely descriptive rather than a pejorative sense, to identify the presence in a work of art of those humanistic referents that have not been wholly subjugated to the interior requirements and rhythms of the work, and which leave a slightly gritty precipitate, extraneous to the solution of the artistic problem. The formal purity of Callahan's pictures expunges the idiosyncratic local color of real life, to give us something better but cooler. His nudes do not propose lust; his

69. HARRY CALLAHAN, *Untitled, 1977. (Original photograph in color).*

forests are free of insects; the pedestrians on his city sidewalks
suffer not as you and I, but as the saints and warriors that are
seen in old museums.

Callahan's show at the Light Gallery, of photographs of
frame houses in Providence (houses that he had already pho-
tographed in 1963), was marked by a characteristic formalism,
deliberation, and single-mindedness, and by a typical contin-
uing obsession with a subject. But, uncharacteristically, the
pictures were in color. I think it was this "vulgar" touch, this
concession to the childish (human) craving for pleasure, that
broke down my resistance to Callahan and permitted me to
experience one of those rare moments of aesthetic joy (akin to
the well-being one actively feels on recovering from an illness)
that arrive when one is suddenly able to appreciate, under-
stand, and enjoy what has hitherto been thwarting, boring,

70. HARRY CALLAHAN, *Untitled*, 1977. *(Original photograph in color)*.

off-putting. Looking at these pictures, I felt the greatness that I once merely accepted other people's word for.

The pictures are portraits. The houses (one or two of them) sit there before the viewer like people who have come to a photographer's studio to have a likeness made; they are elderly, mildly shabby, respectable lower-middle-class houses of plain rectangularity, painted pastel colors, with contrasting trim [69, 70]. They are of the period and partake of the plain vernacular beauty of Walker Evans' photography of the thirties. But small, subtle details—TV antennas, plastic garbage bags, red-and-white "NO PARKING" signs, a printed sheet in a grocery-store window reading "FAMILY PAC ICE CREAM HALF GAL. 99¢"—tell us that we are in the seventies, not the thirties. These color pictures are handsome painterly abstractions, but they are also poignantly evocative. They have taken on an emotional color as

well—one that is lacking in the black-and-white versions. They evoke what we see when we drive through small New England towns. They exude a Hopper-like sense of the loneliness and emptiness of such places (there are no people here, as in the comparable Hoppers), of the small-town willingness to accept the wistfulness and unfulfillment that underlie provincial peace and security. There is a marvellous interplay between the abstract form and the emotional content of the pictures: they are not less truthful because the photographer has sought to make them beautiful; they express the more comprehensive, if not higher, truth of art. It is the absence of this kind of ordering that makes itself felt in the work of avant-garde photographers like Eggleston and Shore and that makes so much of their realism look like triviality.

Another element must be considered in accounting for the immense power and presence of these pictures of Callahan's. It is that they were taken with a wide-angle lens, which has great depth of field and produces a profound distortion. The pictures, consequently, are not normal: their perspective is strange, and the houses loom and threaten, as if they had been taken from the vantage point of a recumbent drunk. Their extreme unnatural angles are like those of *The Cabinet of Dr. Caligari*; their atmosphere of suppressed menace is like that of Magritte. As one restudies the pictures in terms of this "abnormality," one realizes that it is from a photographic exigency that the painterliness of the works derives. Callahan uses a mechanical limitation as a stylistic expansion: what Hopper achieved with drawing, Callahan achieves with optical laws. And in this he is doing conspicuously what other painterly photographers—Weston, Strand, Evans, Kertész—have done more covertly. For if you scratch a great photograph you find two things: a painting *and* a photograph. It is the *photographic means* with which photography imitates painting that produce a photograph's uniqueness and aliveness.

The exhibition of Stieglitz's photography collection at the Metropolitan Museum last summer vividly illustrated this fact, by negative example. The exhibition included works by nine-

teenth-century European and American photographers which simply tried (and often succeeded, to maddeningly boring effect) to look like etchings or reproductions of paintings. The Photo-Secession works, in contrast, always looked like photographs, even though their point of reference was Symbolist, Pre-Raphaelite, or Impressionist painting. They reflected the realization that the art of black-and-white photography is the solving of special problems of design through manipulation— not of negatives and prints with chemicals but of light. Although the Photo-Secessionist photographers went on messing with gum-bichromate and other painterly printing devices, the distinction, the difference, in their work lies in its strong design, in its disciplined contrast of tones, in its stylization, which is similar to that of the various Art Nouveau styles but is achieved by photographic stratagems. In this sense—in their involvement with photography's processes—Stieglitz, Steichen, White, Käsebier, and the others foreshadowed the modernism of Frank by a good fifty years.

Indeed, since photography's earliest days its practitioners have been suspiciously examining their medium and asking themselves what it is. The modernist preoccupation with the form rather than with the content of art is photography's native, inherent preoccupation. When Szarkowski observed that "whatever else a photograph may be about, it is inevitably about photography," he was stating the special metaphoric connection of photography to modernism—a connection that Stieglitz must have sensed when (giving other reasons) he began to show avant-garde painting and sculpture together with Photo-Secession photographs. It must have felt right to do so; the fundamental modernism of the Photo-Secession works transcended the older painting styles of the nominal models, and made them part of the world of Picasso, Brancusi, Rodin, Marin, Dove, O'Keeffe. Similarly, the apparent differences between today's photographic avant-garde and the old guard are not as great as the hidden affinities. We have seen that Callahan's pictures "call attention to art" no less insistently than Sonneman's. The two of them arrive at different conclu-

sions about the nature of photography, but they ask the same questions, and questions are what matter, of course.

1978

Artists and Lovers

INNOCENTLY OPENING THE BOOK *Georgia O'Keeffe: A Portrait*, by Alfred Stieglitz, published by the Metropolitan Museum on the occasion of its exhibition of the same photographs, is like taking a little drive in the country and suddenly coming upon Stonehenge. The series of fifty-one photographs of O'Keeffe's face, hands, and naked body (selected from a group of about five hundred photographs taken between 1917 and 1937, some of which have been shown and reproduced but never before collected) is Stieglitz's posthumous masterpiece, one of photography's monuments, and a tour de force of offset printing. Stieglitz was on the whole opposed to any reprinting of his pictures. "My photographs do not lend themselves to reproduction," he wrote to a publisher in 1931, and went on to explain, "The very qualities that give them their life would be completely lost in reproduction. The quality of *touch* in its deepest living sense is inherent in my photographs. When that sense of touch is lost, the heartbeat of the photograph is extinct. In the reproduction, it would become extinct—dead. My interest is in the living. That is why I cannot give permission to reproduce my photographs." This letter is quoted in the text that Dorothy Norman wrote for the Stieglitz volume in Aperture's History of Photography series, and the inadequate reproductions in the book, including some from the O'Keeffe series, bear out Stieglitz's objection all too well. In amazing contrast, the reproductions in the new Metropolitan Museum book are

near-replicas of Stieglitz's palladio and gelatin-silver prints, somehow retaining the tactility of the originals. Richard Benson, who made the printer's negatives, and Eleanor Caponigro, who supervised the printing process, are the persons chiefly responsible for this impossible-seeming feat. A comparison of the original prints in the show with the reproductions in the book revealed only a few tiny discrepancies, and these mainly in the earliest palladio prints. To this viewer's mind, the occasional small losses in the reproductions were more than made up for by the opportunity for slow, quiet perusal that the book offers and that the crowded museum show (and the crowd-reflecting glass in front of the prints) did not. Not since the days of *Camera Work* has there been such a book of photographs.

If the quality of the reproductions restored the O'Keeffe pictures to their rightful preeminence in Stieglitz's œuvre, their collective presentation was another act of restoration. O'Keeffe's face is one of the most famous in art. The name immediately evokes the image of the grave, gaunt, enigmatic woman—neither young nor old but possessed of a sibyl's beautiful, strange, dark, sorrowing agelessness—that Stieglitz's photographs have etched into the public consciousness, and that by its very vividness has engendered an odd confusion between the woman, her art, and the photographs. The art critic Sanford Schwartz has pointed out the influence of the Stieglitz photographs on the public reception of O'Keeffe's paintings; presumably, if an unphotographed nonentity had done the same paintings they would not have achieved the renown they achieved as Georgia O'Keeffe's work. Conversely, if Stieglitz had photographed a Queens housewife rather than America's leading avant-garde woman painter, the photographs, too, would have been differently regarded. Until the publication of this book, Stieglitz's role in the O'Keeffe photographs was minimal, almost incidental, somewhat akin to that of the shadowy escort of the beautiful model in a fashion photograph. So strong is the identification of O'Keeffe with her photographed likeness that the photographs have seemed to

belong among *her* works rather than among Stieglitz's. The book firmly restores the photographs to their rightful maker. Seeing them together, in chronological order, as in an artist's retrospective, we are in a position to perceive that our image of Georgia O'Keeffe is an artist's invention—the O'Keeffe in the photographs is to the real O'Keeffe what the Saskia in Rembrandt's paintings was to the real Saskia. In this collection, O'Keeffe the famous woman artist recedes and Stieglitz the great photographer moves to the forefront. The "portrait" is a self-portrait.

The man who emerges from it is hardly the same Stieglitz —the pompous, sententious, petulant, cold, sexless old maid —who came out of Dorothy Norman's worshipful and naïvely devastating biography. The man who took the pictures of O'Keeffe is a person of evident warmth, passion, erotic imaginativeness, and assured masculinity. The early pictures in particular—made in the various borrowed studios and apartments where the couple lived before their marriage, in 1924—demonstrate Stieglitz's capacity for love and sex. In her introduction, O'Keeffe, now ninety-one, playfully recalls this period:

> He began to photograph me when I was about twenty-three. [She was actually about thirty.] When his photographs of me were first shown, it was in a room at the Anderson Galleries. Several men—after looking around awhile—asked Stieglitz if he would photograph their wives or girlfriends the way he photographed me. He was very amused, and laughed about it. If they had known what a close relationship he would have needed to have to photograph their wives or girlfriends the way he photographed me—I think they wouldn't have been interested.

Weston's nudes, compared to Stieglitz's, seem almost timid and repressed. One Stieglitz nude, of 1918 (never before published)—a torso cropped at the chest and mid-thigh— stands out from the rest in its blunt sexuality. The picture is taken from below, from a gynecologist's vantage point. The model sits with her thighs open, a robe pushed aside to show

breasts and stomach and pubic hair and labia. Because of the camera's foreshortening angle, O'Keeffe's slender body here assumes a Léger-like squatness and massiveness: the breasts are heavy and pendulous, the pelvis looks broad, the thighs are thick. What gives the picture its tremendous erotic impact is, paradoxically, the very thing that saves it from being lewd and unprintable in an art book. The photograph is printed to darken out the particulars of the genitals: the dark pubic hair merges with the darkness below and forms an enormous black place at the lower center of the picture which dominates the composition—drags the eye to itself, as an abyss compels the gaze of the vertiginous into its fathomless darkness. The photograph is an "equivalent" (to use Stieglitz's term for what he thought a photograph should always be) of a feeling of the time about sex, which reached its apogee in the novels of D. H. Lawrence, as a dark, heavy, mysterious, symbolic, profoundly serious, almost religious experience. It evokes, too, the powerful sex/death-fusing metaphor of another contemporary writer, E. M. Forster—the metaphor of the cave, in *A Passage to India*, where Mrs. Moore endures the horror of cosmic "panic and emptiness." And, finally, it illustrates, fifty years before its time, and better than anything else yet done, the current feminist ideal of woman as large, strong, assertive, authentic, unself-conscious, independent of male approval (and, if it comes to that, male desire)—in every way the opposite of her small, soft, ingratiating, coyly seductive predecessor. (Compare François Boucher's delectable "Miss O'Murphy," lolling on her cushions in her boudoir, with the Stieglitz nude O'Keeffe for the full force of the latter's radical feminism.)

A nude done the following year dwells on a different facet of the female body: its soft voluminousness, its maternal comfortableness, its yieldingness and vulnerability. The work is an abstraction, cropped to include only breasts, segments of the arms, a section of stomach, a brief excerpt of pubic hair. It is printed light—a uniform flesh tone—with the forms of breasts and arms emerging as if modelled by the pencil of a Renaissance master. But though the work has the quality of a drawing,

it is supremely photographic, illustrative of the heightened realism that photography achieves through the ellipsis of its framing. We can extrapolate the whole woman from the fragment, but our sense of the poignancy of the pose and the simple humanity of the body is the more profound because we are shown only the essential extract, the heart of the matter, the source of our emotion. The camera "sees" the world with a poet's or a dreamer's loaded selectivity, and meta-photographs like this one can tell us better than any formal analysis what photography is.

In another photograph of this period, O'Keeffe appears in a white embroidered robe, her hair long and wild, her hands at her breast, her face staring out at the viewer like the face of one of Munch's dishevelled madonnas, with a terrible look on it of abandon, loneliness, sadness, abstraction. Another photograph evokes Munch in another way: here O'Keeffe stands in front of one of her drawings looking gravely downward, her arms lifted over her head, the elbows angled, the palms and fingers spread as if fending off some horror—a gesture that evokes the face in Munch's *The Cry*. O'Keeffe's hands are the collection's leitmotiv: they weave through the pictures, sometimes with the face, sometimes alone, sewing, holding an object, caressing the wheel of a car, gesticulating—always expressive and strange and beautiful and tense.

As one studies and restudies these photographs of a woman whose rare smile is even more sad than her usual grave countenance, one is forced to reexamine the relationship between the young painter and the middle-aged photographer, and to question one's first impression of it as a conventional bohemian romance. These are not mementos of a lover's tender abandon but products of an artist's cold calculation; they have the impersonality, disinterestedness, exploitativeness of art. And they are a collaboration. For the model is no mere love or art object but an artist herself, who is colluding with the photographer, helping him create art. (In this sense, then, the photographs *do* belong among O'Keeffe's works as well as among Stieglitz's.) But along with the serenely collaborating artists,

another couple emerges from the O'Keeffe portrait, and this is the human couple—a man and a woman who did not find agreement and peace, and whose clashing wills, desires, expectations, reserves, and ideas about each other invade the photographs with their contrapuntal atmosphere of tension and discord and difficulty.

The testimony of the pictures is confirmed by the words of O'Keeffe. In her introduction, she discusses her relationship with Stieglitz with startling candor—candor that may not be possible before one is ninety:

> . . . His power to destroy was as destructive as his power to build—the extremes went together. I have experienced both and survived, but I think I only crossed him when I had to—to survive.
>
> There was a constant grinding like the ocean. It was as if something hot, dark, and destructive was hitched to the highest, brightest star.
>
> For me he was much more wonderful in his work than as a human being. I believe it was the work that kept me with him —though I loved him as a human being. I could see his strengths and weaknesses. I put up with what seemed to me a good deal of contradictory nonsense because of what seemed clear and bright and wonderful.

What Stieglitz had to put up with from O'Keeffe is not known, but it is evident that her physical attributes were an important claim on his continuing interest. Yeats's observation that "love comes in at the eye" has particular application to a photographer, whose eye is his everything. O'Keeffe's was a face that could have launched a thousand photographers. (Note its resemblance to that of the unforgettable sharecropper's wife which helped launch Walker Evans.) It had a structure and linearity, a surface expressiveness that are rare; most faces do not photograph as O'Keeffe's does, are robbed of their character and aliveness by still photography's stillness. Stieglitz delighted in the appearance of his mistress and wife as he delighted in the appearance of other photographic "naturals":

the look of the city in snow, of horses in motion, of locomotive smoke, of storm clouds, of street lights at night. Casting one's mind over the known Stieglitz works, one is struck by their narrow range and small number. What Stieglitz didn't photograph may be as much his greatness as what he did. (There are good photographers who might elevate themselves to the ranks of the great simply by burning most of their work.) Stieglitz understood photography better than any photographer before him; he grasped its paradoxical relationship to painting and drawing, seeing that a photograph is most truly photographic when it is openly a parasite of a painting or a drawing—that photography must not *imitate* art but may legitimately *feed on* it.

The O'Keeffe portrait ends in the early thirties, when O'Keeffe was in her mid-forties. About this time, Stieglitz began photographing his future biographer, Dorothy Norman, who appears in his shadowy abstract pictures as a handsome young woman with a perpetual extremely pained expression. If the O'Keeffe portrait adds a warmer, sensual dimension to the dour hero of the Norman biography, it does not, in the end, efface or replace him.

1979

Regrettably, Georgia O'Keeffe, custodian of the Alfred Stieglitz estate, would not give permission to reproduce the photographs discussed in this essay.

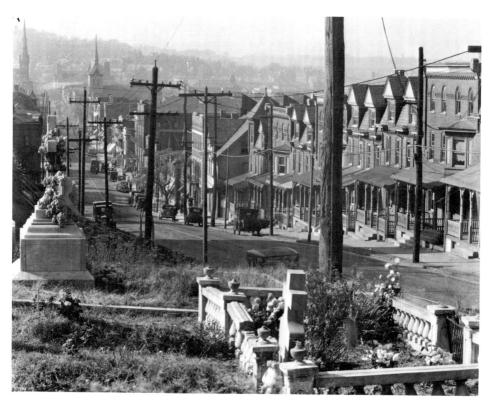

71. WALKER EVANS, *Street and Graveyard in Bethlehem, Pennsylvania*, 1936.

Slouching Towards Bethlehem, Pa.

In an essay of unforgettable brevity and authority entitled "Walker Evans, Robert Frank and the Landscape of Dissociation," published in *artscanada* in 1974, a professor of English named William Stott compared the photography of Evans and Frank, reading in the "stately populism" of the former an expression of the innocent optimism of the thirties, and in the disdain of the latter the educated despair of the sixties. Of Evans, Stott wrote, "In the lives and appurtenances of working-class and Depression poor, Evans found a beauty of such strength and dignity as to command the respect of anyone with eyes." Frank, in stark contrast, "shows us a land of sullen people, bored, phlegmatic, nasty in their emptiness; a land in subjugation to prefabricated things and pleasures; a land of anomie, where the television set and juke box have replaced humans as the center of energy in the room." Stott went on to say that "whereas Evans showed his people to be aesthetically respectable, and thus morally worthy, Frank used his people's lack of taste and vigor to condemn them; theirs is a true poverty, a poverty of the spirit." He cited Evans' picture of a corner in a coal miner's shack, showing a rocking chair, a broom, and advertising art tacked to the wall, as evidence of the irrepressible humanism that soared over the poverty and misery of the Depression: "Evans' people, for all their reserve, were not passive before the junk of modern commerce; in a characteristic

72. WALKER EVANS, *Independence Day, Terra Alta, West Virginia*, 1935.

picture, Evans showed how a West Virginia coal miner used a Rexall poster and a Coca-Cola Santa Claus to give some color and warmth to the cardboard walls of his carefully swept living room." Opposite this photograph Stott showed Frank's picture of a California diner and pointed out that "in Frank's America, a plastic Santa above a diner counter becomes just one more piece of crud on the wall. The Santa smiles, but here only unreal people—plastic people, like beauty queens and TV hostesses—smile; real people, like the waitress in the diner, have dead eyes and clenched teeth." Stott went on to discuss the stylistic and technical differences between Evans and Frank—the deliberate, craftsmanly formalism of the former and the messy, blurred, tilted, grainy, shooting-on-the-run snapshot style of the latter—as further corroboration of their fundamental ideological incompatibility.

Last year, a large new collection of Walker Evans' photographs, entitled *Walker Evans: First and Last* (Harper & Row), appeared, and Frank's *The Americans* of 1959, long out of print, was again made available by Aperture. While perusing the two

73. WALKER EVANS, *Waterfront Poolroom, New York City,*
1933.

books, with Stott's essay in mind and with a view to collecting
fresh instances of, on the one hand, Evans' serene aestheticism
and humanism and, on the other, Frank's chaotic nihilism, I
found myself becoming aware, with growing perplexity, of
exceptions, on both sides, to the Stott polarity. The Evans book
is not the anthology of grace and order it should have been. It
is a book full of chaos and disorder, of ugly clutter and mess, of
people with dead eyes [72], victims and losers crushed by the
indifferent machinery of capitalism, inhabitants of a land as
spiritually depleted as its soil was physically eroded. The more
I looked at it, the more the book appeared to me as a kind of
guidebook to a journey through the underworld—a landscape
as sterile as the moon's (one of the first pictures in the book is
of the Luna amusement park at Coney Island), imagined in
terms of a deadly iconography. A ghostly abandoned pool hall

74. WALKER EVANS, *Joe's Auto Graveyard, Pennsylvania*, 1936.

on the New York waterfront [73]; a mound of earth that is a
child's grave [76]; an automobile graveyard [74]; a street in the
rain with identical black cars parked at identical angles, as if
mourners at a universal funeral; a row of workers' houses
dwarfed by satanic mills [75]; empty streets; empty churches;
people walking on the street with the faces of the damned or
sitting on the subway in the state of abstraction and isolation
that gives a living face the look of sleep and death: man as
shade. These are some of the volume's characteristic (and
hardly optimistic) images. The pictures in Frank's *The Ameri-
cans* are "off" in another way. A number of them are as artfully
composed and as pictorially conceived as any by Evans. Only a
few have the requisite messiness, the blurred tiltedness, the
graininess, and many seem more evocative of Evans than diver-
gent from him [77, 78, 79]. They show what Frank has always
acknowledged: his heavy debt to Evans.

That the 1978 edition of *The Americans* should reflect the
influence of Evans on Frank and underscore the similarities of
the two photographers, while the 1959 edition largely stunned
the public with its outrageous newness and rawness and
unlikeness to anything that had come before, is an instance of
a common enough phenomenon. It takes a while for new works

75. WALKER EVANS, *Steel Mill and Workers' Houses,
Birmingham, Alabama*, 1936.

of art to settle into the tradition out of which they came. Or, rather, the dust that the difference between the old and the new throws up has to settle before the relative smallness of the difference is perceived and the connection to the past is established. This settling had evidently not yet taken place when Stott wrote his essay. Nor had its corollary process—the alteration of the past by the present, which accounts for the mysterious difference between the Evans anthology of the thirties and the one of the seventies. This process was first detected and described by T. S. Eliot in his 1919 essay "Tradition and the Individual Talent." The well-known passage lays down the principle that:

76. WALKER EVANS, *Child's Grave, Hale County, Alabama,* 1936.

*what happens when a new work of art is created is something
that happens simultaneously to all the works of art which pre-
ceded it. The existing monuments form an ideal order among
themselves, which is modified by the introduction of the new
(the really new) work of art among them. The existing order is
complete before the new work arrives; for order to persist after
the supervention of novelty, the* whole *existing order must be,
if ever so slightly, altered; and so the relations, proportions,
values of each work of art toward the whole are readjusted;
and this is conformity between the old and the new. Whoever
has approved this idea of order, of the form of European, of
English literature will not find it preposterous that the past
should be altered by the present as much as the present is
directed by the past.*

77. ROBERT FRANK, *Car Accident, U.S. 66 between Winslow and Flagstaff, Arizona,* 1955–56.

Accordingly, the arrival of Frank altered the work of Evans; the post-Frank Evans is as different from the pre-Frank Evans as, say, the post-Eliot Marvell is different from the pre-Eliot one. Frank's hellish journey through the America of 1956 was a necessary prologue to the vision of hell that emerges from *Walker Evans: First and Last.* In photography, as in literature, the alteration of the past by the present is achieved partly through changed evaluations of works in the artist's œuvre: at different times, different works come into prominence, while others recede. The new Evans collection differs from previous ones largely in its addition of pictures taken by Evans in the sixties and seventies and also of pictures taken in the thirties and forties which pre-Frank judgment had passed over. And the old core of Evans classics is inevitably, if subtly, affected by its new context. Familiar images, like the tenant farmer's wife,

78. ROBERT FRANK, *Cafe, Beaufort, South Carolina*, 1955–56.

the studies of architectural ornament and advertising art, the interior of the West Virginia miner's cabin that so moved Stott, seem to be different pictures. In some cases, they literally are: in the new book, the cabin interior, for example, is a slight variant of the one that Stott published in *artscanada*. Evans was evidently not content to click the shutter and walk away when he made a photograph but would cautiously take the picture several times, to get it exactly right. If you look closely at the Stott version, you will see on the left side, intermixed with boxes and vague shapes, what may be a bit of skirt and arm. This suspicion is confirmed by the version in *Walker Evans: First and Last,* which shows that a woman was indeed sitting there, not quite out of the picture; it shows a blurrily moving hand as well as the skirt and arm. Evans evidently took the picture again and discarded the version with the hand as spoiled. (In the 1938 collection of Evans photographs, *American*

79. ROBERT FRANK, *Rooming House, Bunker Hill, Los Angeles,*
1955–56.

Photographs, published by the Museum of Modern Art, the picture appears cropped to exclude all trace of the woman.) In 1978, however, the makers of the anthology, guided by a different aesthetic, seeing the hand not as a distracting flaw but as an expressive element, dug up the variant. With this addition, and with the exquisitely lucid and detailed printing of the new book, the photograph can no longer be viewed as the apotheosis of the "poor but clean" romance. It becomes a picture not of uplift but of irony. That broom standing against the wall has swept clean, to reveal a piece of linoleum so disgracefully tattered and chewed that it would have been better left hidden under dust, and a floor so grittily rough that one can almost feel the splinters in one's foot; the wall it leans against is a crumbling collage of bits of cardboard and tin nailed together. The central advertising sign shows two smiling young people in caps and gowns, and its message reads "Buy Graduation Gifts Here"—this in a house where the children can scarcely finish grade school. The bit of woman is like a bit of refuse swept into a corner—like all the others of her sort who are swept out of sight in the illusory world of American advertising. The bentwood rocking chair below the advertisements sticks out in its serene vernacular handsomeness—and in its emptiness, both literal (the woman, significantly, isn't sitting in it) and metaphorical. It is an object that doesn't belong in this house. It has washed up here as discrepant objects do in the houses of the poor—discards of the better-off. It is as alien to the reality of this interior as are the smirking graduates in the advertisement.

The picture of the tenant farmer's wife in the new book offers another telling contrast when compared to the version published in Evans' *American Photographs,* of 1938. Here, again, a slight variant—a picture taken a moment before or after the other—is involved. The 1938 version shows a young woman of the most delicate, aristocratic beauty, with elegant bones, clear eyes, and smooth white skin, gazing confidently into the camera with a slight smile of humorous indomitability on her lips —a woman who, in her poverty, has the sort of profound beauty that her more fortunate sisters may envy but will seek

in vain at their hairdressers' and dressmakers' [80]. The version in *Walker Evans: First and Last* shows an ugly hag, her face covered with lines and wrinkles, her brow furrowed with anxiety, her mouth set in a bitter line, her eyes looking out in the expectation of seeing nothing good [81]. What one feels looking at this portrait is no longer envy but outrage at the conditions that should have turned a beautiful woman into such a defeated and desexed being—a member of what James Agee, writing in *Let Us Now Praise Famous Men* (1939), called "an undefended and appallingly damaged group of human beings." The photograph of the sharecropper's wife that appears in Agee's book gives the same impression of beauty and indomitability as the one in *American Photographs,* even though it comes from the same negative that is used in the 1978 book. The poor printing of forty years ago did a cosmetic job, washing out lines, smoothing out the brow, minimizing the damage. The printer of the new book has performed an act of restitution, and his mercilessly scrutinizing prints are consequently more in line with Agee's text than those that appeared with it. This has always been the problem with Agee's book: the pictures and the text don't agree. The text is a howl of anger and anguish over the misery of the sharecroppers' lives. "How can people live like this? How can the rest of us permit it, tolerate it, bear it?" Agee cries. "Don't listen to him," the serene, orderly Walker Evans photographs seem to say. "He exaggerates. He gets carried away. It's not as bad as he says."

In all probability, Walker Evans himself believed nothing of the kind. The disparity between the testimony of his photographs and that of Agee's text comes not out of a disagreement between the two witnesses about what they saw but out of photography's inadequacy as a describer of how things are. The camera is simply not the supple and powerful instrument of description that the pen is. Could a thousand photographs begin to express what the following passage by Agee does?

> *There is even in so clean a household as this an odor of pork, of sweat, so subtle it seems to get into the very metal of the cook-*

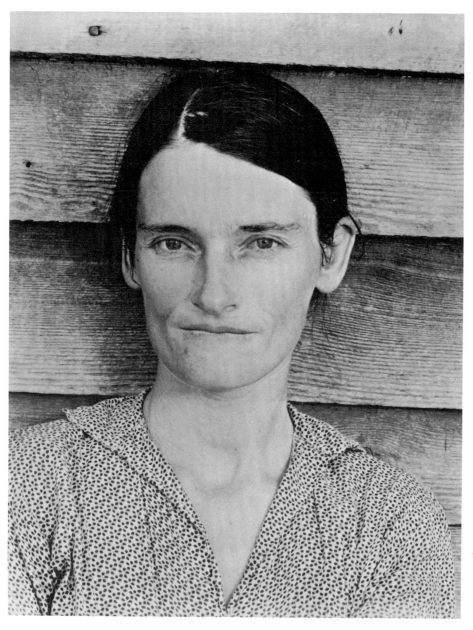

80. WALKER EVANS, *Alabama Cotton Tenant Farmer Wife,* 1936.

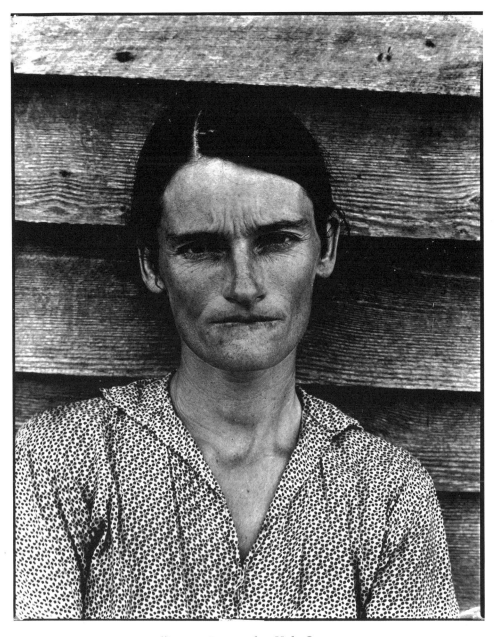

81. WALKER EVANS, *Allie Mae Burroughs, Hale County, Alabama*, 1936.

ing-pans beyond any removal of scrubbing, and to sweat itself out of newly washed cups; it is all over the house and all through your skin and clothing at all times, yet as you bring each piece of food to your mouth it is so much more noticeable, if you are not used to it, that a quiet little fight takes place on your palate and in the pit of your stomach; and it seems to be this odor, and a sort of wateriness and discouraged tepidity, which combine to make the food seem unclean, sticky, and sallow with some invisible sort of disease, yet this is the odor and consistency and temper and these are true tastes of home; I know this even of myself; and much as my reflexes are twitching in refusal of each mouthful a true homesick and simple fondness for it has so strong hold of me that in fact there is no fight to speak of and no faking of enjoyment at all. And even later, knowing well enough of such food what an insult it is to those who must spend their lives eating it, and who like it well enough, and when I am sick with it, I have also fondness for it, and when this fails, a funny kind of self-scorning determination that I shall eat for a few weeks what a million people spend their lives eating, and feel that whatever discomfort it brings me is little enough and willingly taken on, in the scale of all it could take to even us up.

Out of some obscure mistrust (it may be) of the camera's capacity for telling the whole truth, the photographer Chauncey Hare has been moved to preface a collection of his remarkable photographs, *Interior America* (Aperture), with a starkly intimate account of his own life. This preface—in its sadness, bleakness, and flatness of emotional tone—puts one in mind of the final chapters of *The Way of All Flesh*. Like Ernest Pontifex's, Hare's history is one of almost unrelieved pathos. Unlike Ernest, who was bloodied and bowed by Victorian hypocrisy, Hare sees himself as the victim of the less overtly cruel but just as deadly modern disorder of alienation. He was born in 1934 in Niagara Falls, the son of an engineer and a depressive mother who would sometimes lock herself in her room for days. After a

lonely childhood ("I was undersized, poor in sports, but always at the top of my class"), he entered the Columbia University School of Engineering, because "it just never occurred to me—growing up in that environment—that I would not be an engineer." While at Columbia, he met a quiet young Austrian girl named Gertrude. Although, Hare writes, "Gertrude knew very little English when we met [and] I had only a smattering of German . . . it made little difference, because we did not talk very much." Hare confides that "I never exactly planned to marry Gertrude," but he drifted into marriage as he had drifted into engineering. After graduation, he went to work for the Standard Oil refinery in Richmond, California, where he stayed for twenty years, "discontented from the first day." The technical part of the work agreed with Hare well enough; "the rub was the human side of the refinery—if it could be called that." What Hare calls "the corporate authoritarian ethos" contaminated all relationships between employees at the refinery. In 1958, out of a need for "some kind of escape," Hare bought a camera, and by 1962 he was serious enough about photography to invest in a large view camera. He sees the purchase of the view camera as a symbolic act; it brought into the open the conflict between his hated work at the refinery and his new love, photography. The conflict led to a neurotic symptom: he began to vomit in the mornings. In 1964, he had a show at the San Francisco Museum of Modern Art, and in 1969 he received a Guggenheim grant, enabling him to take a year's leave of absence from the refinery, during which he took many of the pictures of interiors on which his current reputation is based. The vomiting ceased during the Guggenheim year. Meanwhile, his marriage was foundering. Hare writes of "a similarity between my marriage and my father's relationship to my mother—in which the woman was a shadowy, almost insignificant partner," and continues, "Through photography, I had embarked on an exploration of myself, but it was not something I was able to share with Gertrude. We seldom spoke to one another. Even our most intimate moments were less than satisfactory compromises between her instinctive opposition to

birth control and my reluctance to have a child." However, in 1965 a son was born, of whom Hare chillingly writes, "He must have sensed that he wasn't wanted at first: he didn't talk for the first six years." In 1975, Hare and Gertrude were divorced, and in 1976 he left the refinery for good, to devote himself to photography full time. In a postscript to the preface, he writes, "I have been away from engineering for two years and find that the photography world is not unlike the corporate situation from which I narrowly escaped."

In *Interior America*, Hare enters the homes that Frank sped by when taking the pictures for *The Americans*. Hare's photographs are not surprising—they are only devastating. The shock of recognition makes one wince as one turns the pages. He shows us to ourselves as perhaps no other documentary photographer has ever done. The significant word here is "us." Other documentary photographs are about "them"—are taken by photographers working like anthropologists observing an alien culture. Frank's pictures, for example, shimmer with a Nabokovian innocence and irony; they work, because Frank's position is authentic: he *is* someone from another culture (or, at any rate, he was when he took the pictures), while those of Frank's American imitators, who have no business looking at things as if for the first time, merely seem contemptuous. Hare's vision is the knowing and intimate, loving and hating vision of the insider; the quality of "home" that Agee identified in the awful/wonderful food is present in Hare's pictures, and his pictures hurt because they *strike* home: they are not about people different from us—people with worse taste, worse habits, worse values (though God knows the book does not lack for reproductions of *The Last Supper* on flocked felt, plastic flowers, "modernistic" clocks, Mediterranean furniture, pastel drawings of white horses). Hare's intention is not to chastise some but to implicate all. In thinking about how he achieves universality with his almost obsessively particularized photographs, I was reminded of a passage in a letter once written to me by the historian John Kouwenhoven, gently and brilliantly correcting a misconception of mine in an earlier essay:

When we disagree, we do so because we are looking at different aspects of the same thing. I realized this when I thought about your final statement: that the camera is no better equipped than the eye to tell us what we want to know about the world. That seems to me absolutely right. But is it not also so that the camera is better equipped than the eye to tell us what we do not want to know? Our eyes are looking for what we want to know; the camera can be aimed in the direction whence we think that information may come. But left to itself it cannot (as the eye can) limit its attention. It cannot help showing us what we have no interest in seeing.

We have all had the experience of being appalled by the Polaroid or Instamatic snapshots that someone has taken at a party, in which not only we ourselves look terrible but our surroundings do, too. The pleasant and sometimes even expensively furnished room we're sitting in has been transformed into a hideous and cheap-looking mess of lamp cords, wall outlets, TV antennas, cigarette brand names, creased upholstery, dirty plates and glasses, spindly table legs. "What we do not want to know"—and what our Kodacolor snapshots delight in telling us—is that we are all the same. Under the camera's bland, democratic gaze, Astoria and Sutton Place are all but indistinguishable. The electric cord binds us all together; at our most individual we appear as but slightly different brands of consumer.

Hare takes the camera's capacity for aimless vision as his starting point and works with it somewhat the way a psychoanalyst works with free association. He enters the universe of the undesired detail and adopts an expectant attitude, waiting for the cluttered surface to crack and yield to interpretation. Hare's own view of his art, though somewhat mystical, is to the point. "A quality of magic came into existence early in the Guggenheim," he writes. "Things began to happen in an uncanny way. . . . To cite an example, I was in a mission flophouse in Chester, Pennsylvania. I had found the photograph, the camera and light were primed—yet I just couldn't take the picture. Suddenly a man walked out of a door I didn't even

know was there and came toward me. I shot off the strobe light. He glared at me and said, 'You sonofabitch,' and walked on by. That was the picture I was there for. That, to me, is magic." That, to others, is everyday creativity—is Cartier-Bresson's aliveness to the "decisive moment," is Robert Frost's delight in "the surprise of remembering something I didn't know I knew." The picture that Hare cites does indeed owe its existence as a photograph to the *deus ex machina* of the glaring man. The picture shows a dormitory of neatly made metal cots, with various articles of clothing hanging from wire hangers on nails in the walls, toilet articles arranged on bedside tables, towels draped on bedsteads, cupboards with miscellaneous cardboard boxes and vague, forgotten junk on top of them, and, on one of the cots, a small middle-aged man wearing a checked shirt like one of those on the hangers; he is lying on his back and reading, with the grim attention of someone studying *Principia Mathematica*, a *Jughead* comic book. To the left of him, down the aisle between the rows of beds, comes a tall, fat man wearing a tight overblouse and baggy cotton pants and carrying a small, mysterious package in his left hand—a type one recognizes and watches out for, a sullen bully. The "meaning" of the picture can't be nailed down literally, but it has something to do with—emasculation? One should not bear down on it too heavily (but remember *where* the scene is set).

Hare's pictures have Aristotelian action. A few other photographers of the "snapshot school" have taken pictures with this property—Garry Winogrand, conspicuously—but most snap the shutter too early, before the action begins, before the secret door opens and yields the photograph. A picture taken in Wheeling, West Virginia, of a family watching TV—this is its "action"—is one of the most disturbing images in the book. It shows a man and a woman of lanky build sitting in identical black leather or plastic armchairs, with their long legs stretched out in front of them, and on the lap of each is a small child. All four sit staring at the offstage TV screen as if in a trance. They sit oblivious of and surrounded by scores of little objects displayed on small tables and shelves and étagères: doilies,

ceramic boxes, plastic flowers, decorative ashtrays, miniature figurines, framed photographs, small hurricane lamps. On the wall behind them hangs a large, gloomy work of popular landscape art, ornately framed. The floor is covered with a carpet whose floral pattern, robbed of color, takes on the pitted appearance of the surface of the moon. The scene has the atmosphere of a horror movie. The father is the most powerfully transfixed of the four: his mouth is agape, his eyes are glazed, he looks exhausted and depleted, his shirt is unbuttoned to show his undershirt. One notices that the shirt is torn at the elbow and that the trousers are dirty, and one infers that the man has just come home from work. To put crudely what Hare expresses metaphorically, a member of the alienated work force comes home and permits television to further alienate him from his wife and children. In the discrepancy between the family's physical closeness and its spiritual isolation lies the true horror of the photograph.

One turns the page to find an even more disturbing image. This picture, taken in Berkeley, California, shows a baby in an old-fashioned wicker crib next to a window that looks out on a concrete balcony. On the balcony one can see a part of a mangy dog and a piece of hose, and, beyond, a bush, a Volkswagen, a trailer truck; receding into the distance are various pieces of industrial detritus of an undefined sort. The baby is lying on his back and sucking on a bottle. This photograph points up perhaps more distinctly than any other the quality of a dream that Hare's "action" partakes of, the sense of latent meaning that it quivers with. Everything stands for something else. The window is a glimpse into the mind of the abandoned baby. The view of ugliness and chaos is an objective correlative of a child's feelings of loneliness and confused miserableness when his mother leaves him. The magic here is that of memory. Something must have stirred in Hare's recollection when he came upon the scene (undoubtedly he remembered his own feelings of abandonment when he was little and his mother withdrew from him into depression), and he recognized his metaphor.

Not all the pictures in *Interior America* are as poignant and

disturbing as these. Alienation has its lighter side in a picture set in a kitchen in Richmond, California. Words like "spotlessly clean" and "sparkling white" come to mind as one looks from the gleaming surface of the icebox to the shining chrome legs of the modernistic breakfast table and chairs to the well-groomed, smiling blond housewife, dressed in a sleeveless black minidress and black boots, who sits at the table with one arm around a sparkling and spotless baby and the other extended toward a large tabby cat parked on the table. In the foreground, on a bureau, stands a large box of Purina Gravy Dinner, illustrated with another cat. Pasted on the wall over the table is a reproduction of van Gogh's *Sunflowers*. What is real? Art or Life or Gravy Dinner? One looks at this picture for a long time and never quite unravels its secret conundrum.

In a similar vein of comedy and mystery is a picture of a white frame house on Interstate 80 in California. A low clothes-line in front of the house is strung with garish machine-art tapestries—one of a bullfighter in Toledo, one of horses in a pasture, one of peacocks, and a fourth of a stag and mountains. Signs are hopefully nailed all over the house saying "Open" and "Come In." What gives the photograph its special, Dadaist bizarreness is the fact that in the distance behind the stag tap-estry some mountains are visible, so that for an instant one almost thinks that the stag is real; in the next instant one delights in the horrid incongruity of the fake stag (and horses and peacocks and bullfighter) in the real outdoors.

The disparity between human and photographic vision is mordantly stated in a picture of an attractive young couple and their two small children, in their kitchen, confidently smiling at the photographer, like people posing for their picture in a stu-dio. Would they be smiling as confidently if they saw what we see: an open toilet through the door; a hulking water tank next to them, with a coffee can perched on it; an open can of grease on a shelf above the stove; a meaningless meander of wiring on the wall? The art of the portrait, a picture like this teaches, is the art of the Potemkin village.

One of the most powerful and emotional, though least

showy, images in the book is that of an older working-class couple in their home in Sacramento Valley, California—a picture that, in perverse refutation of what I said above about photography's limitations, is in its way as evocative as the writing of Agee. Hare has somehow got the smells of the place into his photograph—the smell of the kerosene stove in the left background and of the stout elderly woman seated in the right foreground, who is wearing an apron over a sleeveless housedress, whose white hair is pulled back, who wears glasses, whose forearms are fat and tanned. One knows this old lady. One knows her faint, neither unpleasant nor pleasant odor—the odor of real life—and one knows the slow-moving, deliberate way she walks and the slightly-hard-of-hearing way she will listen to you and slowly, skeptically nod her head. Her husband sits by the stove with a pensive German shepherd tucked under his arm. He wears overalls and work boots; he is thinner and younger-looking than his wife. (The artificial chronological disparity between working-class wives and husbands is another recognition.) The room in which the couple sit is a benignly disorderly collection of utilitarian and homey decorative objects—china and bibelots on shelves, piles of papers and magazines, a metal tackle box, a birdcage, a never used set of silver spoons, ruffled white gauze curtains, a wall calendar. The man and woman and dog gaze in different directions, each in a moment of reverie, far away from "the things of this world" and yet in the midst of them, grounded by them, and (for once) not alienated because of them.

Like Frank's pictures when they first appeared, Hare's pictures are more striking for their difference from their predecessors than for their connectedness to them. And yet in two pictures in *Interior America* Hare himself looks backward, openly taking as his *données* a classic work by Russell Lee and one by Walker Evans. The Lee work is the wonderful 1939 photograph that appears on the cover of the new collection, *Russell Lee Photographer* (Morgan & Morgan), of the elderly couple in Hidalgo County, Texas, sitting in respectful symmetry around their magnificent floor-model radio of Aztec Modern design,

82. RUSSELL LEE, *Couple in Hidalgo County, Texas*, 1939.

she sewing and he leafing through a magazine [82]. Over the enormous radio (which had taken the place of the hearth in 1939, with people warming themselves around its songs and comedies and romances) hangs a machine-art tapestry printed on black cloth and depicting a scene from a French rococo court, with aristocrats in powdered wigs graciously gathered about a harpsichord. The stout, swarthy American woman's head is covered with a black hairnet, to keep her pincurls in place, and her stockingless feet are comfortably encased in disreputable laceless shoes. The husband's right sock has an enormous hole at the ankle, about which he is equally unconcerned. This picture's life—its "action"—comes out of the contrast between Art Deco and life plain (and homely and poor), but its irony is gentle and good-humored. (Indeed, Stott's characterization of warm-hearted humanism and optimism applies better to Rus-

sell Lee than to Evans.) The irony of the Hare version of this scene, taken in Steubenville, Ohio, in 1971, is bitter and unforgiving. It shows a couple in the same symmetrical arrangement around another domestic shrine—a marble fireplace of the most ludicrously elaborate ornateness, which continues rising upward, with carved display cases and shelves on which candelabra and figurines and bric-a-brac daintily sit, long after other fireplaces have subsided; below, it is fitted with a fancy brass grate in which, obviously, nothing so crass as a log has ever reposed. We are in affluent America now, and the couple are a different breed from the pair in the Russell Lee picture. He is wearing a white jacket and a dark tie, and dark trousers with a sharp crease, and good shoes; a tall man in his sixties with bland good looks, he is gazing at the photographer with the slightly fixed smile of a corporation executive in a Bachrach photograph. She is a plump woman of the same age, wearing a bridge-luncheon linen dress and white pumps; she has a vague, fuzzy look about her, and seems to have fallen asleep during the sitting. (People discovered sleeping in living rooms is one of the leitmotivs of *Interior America,* as if in paraphrase of Villiers de l'Isle-Adam's line "Live? Our TV personalities will do that for us.") On a pedestal table beside the nodding woman is the ubiquitous TV set. The well-heeled worshippers at the empty altar have lost the companionableness of the impoverished Russell Lee pair: they look unconnected and dissociated. The Russell Lee picture was taken at a distance that put the people in a natural relationship to their background; in the Hare version, the photographer has stepped far back, so that the couple are dwarfed by their large, draperied windows and by the fireplace, and further diminished and dematerialized by the distortion of the wide-angle lens that Hare favors in his interior photography.

The original of Hare's second *hommage* is Walker Evans' 1936 photograph of a street on a hill in Bethlehem, Pennsylvania [71]. There is a graveyard in the foreground (from within which the picture is taken), and as the camera sweeps down the long, sloping street it quietly and powerfully evokes all such

mill towns that we have driven through, with their rows of shabby frame houses, and their stillness and their decency in spite of poverty and because of mortality. "Death destroys a man: the idea of death saves him," E. M. Forster wrote and this elegiac picture intimates. Hare returned to the same street in 1972, and also took his picture from within the graveyard, though at a spot a bit uphill from where Evans stood, so that in the foreground a memorial angel comes into view with bowed head and an arm extended toward the street in benediction and farewell. Behind the row houses (which are unchanged), a big, innocuously ugly multi-story modern building has sprung up in the place of the mills that used to be there. (Another version of the Walker Evans picture shows them more prominently.) In a sense, Hare's picture is an "improvement" on Evans'—his placement of the angel as a foreground figure strengthens the composition. But the big modern building invades the street's stillness, and mocks the row houses as anachronisms, and is what the picture is about—the menacingly bland reality that the angel (with Hare) bows her head before.

These "derivative" pictures give clues to but do not answer the question of how Hare will settle into the tradition of Evans and Frank which spawned him, and which he, in turn, will transform. It is too early to tell about Hare's place in photography, but it is still possible to get gooseflesh from his photographs.

1979

Regrettably, Chauncey Hare would not give permission to reproduce any of his photographs.

Bibliography

Agee, James and Walker Evans. *Let Us Now Praise Famous Men*. Boston: Houghton Mifflin, 1960.

Avedon, Richard. *Observations*. New York: Simon & Schuster, 1959.
Nothing Personal. New York: Atheneum, 1964.
Portraits. New York: Farrar, Straus & Giroux, 1976.
Avedon Photographs. New York: Farrar, Straus & Giroux, 1978.

Callahan, Harry. *Callahan*. Millerton: Aperture, 1976.

De Cock, Liliane. *James Van Der Zee*. New York: Morgan & Morgan, 1974.

Doty, Robert. *Photo-Secession*. New York: Dover, 1978.

Emerson, Peter Henry. "The Death of Naturalistic Photography," quoted p. 93 in *P. H. Emerson* by Nancy Newhall, Millerton: Aperture, 1975.

Evans, Walker. *First and Last*. New York: Harper & Row, 1978.
American Photographs. New York: East River Press, 1975.

Frank, Robert. *The Americans*. Millerton: Aperture, 1978.

Gernsheim, Helmut. *Julia Margaret Cameron: Her Life and Photographic Work*. Millerton: Aperture, 1974.

Green, Jonathan. *The Snapshot*. Millerton: Aperture, 1974.

Hare, Chauncey. *Interior America*. Millerton: Aperture, 1979.

Hurley, F. Jack. *Russell Lee: Photographer*. New York: Morgan & Morgan, 1978.

Kirstein, Lincoln and Beaumont Newhall. *The Photographs of Henri Cartier-Bresson*. New York: MOMA, 1947.

Kouwenhoven, John. *Made in America*. New York: Farrar, Straus & Giroux, 1975. Also published as *The Arts in Modern American Civilization*. New York: Norton, 1967.

Lartigue, Jacques Henri. *Diary of a Century*. New York: Penguin, 1978.

Lucie-Smith, Edward. *The Invented Eye*. New York: Paddington, 1975.

Maddow, Ben. *Edward Weston: Fifty Years*. Millerton: Aperture, 1973.

McCullin, Donald. *Is Anyone Taking Any Notice?* Cambridge: MIT, 1973.

Newhall, Beaumont. *The History of Photography*. New York: MOMA, 1964.

Norman, Dorothy. *Alfred Stieglitz: An American Seer*. Millerton: Aperture, 1978.

Penn, Irving. *Moments Preserved*. New York: Simon & Schuster, 1960. *Worlds in a Small Room*. New York: Viking, 1974.

Pommer, Richard. "August Sander and the Cologne Progressives," *Art in America*, Jan.–Feb. 1976, p. 38.

Rosenberg, Harold. *The Tradition of the New*. New York: McGraw-Hill, 1965.

Sander, August. *Men Without Masks*. New York: New York Graphic Society, 1973.

Scharf, Aaron. *Art and Photography*. New York: Penguin, 1974.

Siskind, Aaron. *Places*. New York: Farrar, Straus & Giroux, 1976.

Sonneman, Eve. *Real Time*. New York: Printed Matter, Inc., 1976.

Steichen, Edward. *A Life in Photography*. New York: Doubleday, 1968.

Stettner, Louis. *Weegee*. New York: Knopf, 1977.

Stieglitz, Alfred. *Alfred Stieglitz*. Millerton: Aperture, 1976. *Georgia O'Keeffe*. New York: Metropolitan Museum, 1979.

Szarkowski, John. *The Photographer's Eye*. New York: MOMA, 1966. *William Eggleston's Guide with Essay*. Cambridge: MIT, 1976.

Weston, Edward. *Daybooks of Edward Weston*. Millerton: Aperture, 1973.

Winogrand, Garry and John Szarkowski. *Animals*. New York: MOMA, 1969.

ACKNOWLEDGMENTS

The photographs reproduced in this book appear courtesy of the following collections, agents, and photographers:

David Hunter McAlpin Fund, 1957, The Metropolitan Museum of Art, New York [1, 15]

© 1960 by Irving Penn, courtesy *Vogue* [2, 19]

Alfred Stieglitz Collection, 1933, The Metropolitan Museum of Art, New York [3]

The International Museum of Photography, George Eastman House, Rochester [4, 7]

The Royal Photographic Society, London [5, 44, 45]

© Imogen Cunningham Trust, courtesy the University of Washington Press [6]

Edward Weston Estate [8, 9, 10, 11, 12, 13, 14, 16, 31]

The Museum of Modern Art, New York [17]

© 1949, 1977 by the Condé Nast Publications, Inc., courtesy *Vogue* [18]

The Bibliothèque Nationale, Paris, and S.P.A.D.E.M. [20]

The Calouste Gulbenkian Foundation, Lisbon [21]

Richard Avedon [22, 23, 24, 26, 28, 29, 55, 57, 58, 59]

The Trustees of the British Museum, London [25]

The Sander Gallery, Washington, D.C. [27]

Irving Brown Collection, the State Historical Society of Wisconsin, Madison [30]

The Minnesota Historical Society, St. Paul [32]

André Kertész [33]

The American Museum of Natural History, New York [34]

© J. H. Lartigue/Rapho/Photo Researchers, Inc. [35]

James Van Der Zee [36]

Joel Meyerowitz [37]

G. Botsford [38]

© Robert Frank, courtesy Paul Katz [39, 61, 77, 78, 79]

Nancy Rexroth [40]

Herta Hilscher-Wittgenstein [41]

© Henri Cartier-Bresson, courtesy Magnum [42]

Bequest of Mrs. H. O. Havemeyer, 1929, The Metropolitan Museum of Art, New York [43]

© Donald McCullin, courtesy Magnum [46, 47]

Aaron Siskind [48]

Caldecot Chubb [49, 50, 51, 52, 53, 54]

Joanna T. Steichen, courtesy Julian Bach Literary Agency [56]

Bill Owens [60]

Estate of Diane Arbus [62]

Castelli Graphics [63, 64, 65]

The Light Gallery, New York [66, 67, 68, 69, 70]

The Farm Security Administration, Washington, D.C. [71, 72, 74, 75, 76, 80, 82]

Walker Evans Estate [73, 81]

The photo research was done by June Lundborg.

DIANA & NIKON *was designed by Katy Homans and typeset by Dix Typesetting Co., Inc. in VIP Palatino, a typeface designed by Hermann Zapf. Named after Giovanbattista Palatino, a writing master of Renaissance Italy, Palatino was the first of Zapf's typefaces to be introduced to America. The first designs were made in 1948 and the fonts for the complete face were issued between 1950 and 1952. The paper is Mohawk Vellum, an entirely acid-free sheet. The book was printed by Mercantile Printing Co., Inc. and bound by Robert Burlen & Son, Inc.*